Basic Crime Scene Photography

2nd Edition

By

Aric W. Dutelle, MFS

D1367415

Basic Crime Scene Photography

2nd Edition

Aric W. Dutelle, M.F.S.

To order: ISBN-13: 978-1514334331
 ISBN-10: 151433433X

Printed by CreateSpace, An Amazon.com Company

Table of Contents

6

For my brother…

Acknowledgements

Realizing that I could never remember them all, and will most certainly miss someone, there are a number of people who have contributed to my knowledge of photography over the years and to the content of this text. I wish to thank Dana Cecil, Richard Cowan, the students of "Investigative Photography" at University of Wisconsin-Platteville, Nancy Olds, Dan Gilliam, Doug Kelly, Sandy Weiss, those of you who wished to remain nameless and those who I have been remiss in including.

Thank you each and every one of you for your part in assisting to make this a text worthy of providing proper training and reference for those tasked with such an important part of our criminal justice system.

Introduction

The purpose of crime scene photography is to establish a visual record of the condition of the scene and the items present within it. Depending upon the experience and skill of the photographer, this is accomplished with varying degrees of success.

Building off of the success of the first edition, the purpose of this text is to educate and remind individuals responsible for documenting crime scenes of the methodologies and protocols associated with proper crime scene photography. While basic in nature, this text is intended to serve as a foundation for the principles and methodologies which should be adhered to when conducting crime scene documentation. While many will point to DNA and fingerprint evidence as the forensic evidence most likely to be collected and most likely to lead to a conviction (or exoneration), proper crime scene photography is actually the foundation and arguably the most important physical evidence. Oftentimes, if photographs are improperly taken, or not taken at all, subsequently collected evidence may be ruled inadmissible.

The format of this text is a practical, step-by-step, application of basic techniques associated with crime scene photography. Although written primarily associated with the use of Digital Single-Lens Reflex (DSLR) camera systems, it is intended that the reader will emerge capable of utilizing any camera system, coupled with the aid of the methodology included within this text, to properly document the subject matter confronted within his or her day-to-day activities.

It is the desire of the author to provide those within the field of forensic investigation, as well as those in training, with a foundation in basic crime scene photography. Once the

fundamentals have been established, the reader is encouraged to seek out additional training and work on more advanced concepts and principles to assist with challenges experienced within day-to-day operations.

Although intended to cover the basics of photography, based upon feedback received from the first edition of this text, a number of additional sections have been added. Sections pertaining to photography and use of alternate light sources, basic photography associated with challenging environmental conditions (underwater, rain, etc.) and photography of fire and post-blast scenes are included within this edition. These inclusions, along with corrections and other chapter modifications, has resulted in this edition containing 30% more content than the first edition. Hopefully, this will provide the reader with a multitude of information and the opportunity to gain photographic experience.

Photography is a technical skill and as with any technical skill, the more times that a skill is performed (correctly) the more proficient an individual becomes at the skill. So, whether you are reading this as someone new to photography, or are a seasoned veteran simply looking for an occasional reference, hopefully this text will be of value to you. Continue to take photos and the photos will continue to improve!

Chapter 1

An Introduction to Photography

Chapter 1: An Introduction to Photography

Key Terms:

- Fair and Accurate
- Photography

The word "photography" is derived from two Greek words, *phos,* which means "light", and *graphos,* which means "to write." Therefore, in essence, **photography** best translates to mean "to write with light." This is essentially the purpose of any camera, whether modern day or antique.

The modern camera and its components will be discussed within Chapter 2, for now let us discuss how the act of writing with light relates to crime scene documentation.

Artistic Versus Crime Scene Photography

Crime scene photography is similar in some respects to other types of photography, but there are some important differences to be noted. The primary difference between artistic and crime scene photography is that with crime scene photography, your work will be scrutinized not for its artistic content but rather for the accuracy with which it depicts the subject matter photographed. This is not to say there is no creativity employed within crime scene photography. At times, the photographer may need to be very creative to properly accomplish a shot which is a true and accurate photograph. However, instead of the creativity being the intent of the photograph, any involved creativity on the part of the photographer should go almost entirely unnoticed.

With crime scene photography, there is intent behind every photo. The angle, range, perspective and lighting are all used in

a manner meant to reflect a true and accurate representation of how the subject matter appeared to the photographer at the time that the photo was taken. Any variation from reality is improper and could result in the image being ruled inadmissible within a court of law. Typically, with creative photography, angle, range, perspective and lighting are used to distort, blend, hide, or reveal aspects within a photograph in an effort to awe the viewer. This should never be the case within crime scene photography.

Purpose of Crime Scene Photography

Rather than awe the viewer, the intent of crime scene photography is:

- To capture the subject matter in a manner which properly displays a true and accurate representation of the subject.
- To assist with refreshing the recollection of those who were present at the time that the photographs were taken.
- To visually transport the trier-of-fact to the location where the photos were taken.

The purpose of crime scene photography is to capture adequate images for the best possible documentation and reproduction of the reality present at the moment in time when the scene was photographed. When attempting to do this, it must be remembered that, photography is a mechanical means of retaining vision. When properly taken, a photograph is one of the only ways to stop and capture time. However, the camera was never intended to replace vision, because it certainly cannot. Crime scene photography is visual storytelling, and as such, the photographs should be a fair and accurate representation of the scene about which the story is being told.

Fair and Accurate

For almost 150 years, graphic images of evidence associated with crime scenes have been presented within courts. In each case, admissibility of the images is decided upon by the presiding judge or magistrate. Photographs are almost always admitted due to the fact that they are typically only representative of items of evidence and are not evidence itself. The single most important requirement of a photograph in order that it be admissible is that it be a **"fair and accurate"** representation of the subject matter within the resulting image.

Sandy Weiss, a respected photographer within the forensic imaging community discusses the concept of "fair and accurate" within *An Introduction to Crime Scene Investigation*, 2nd Edition (2013), by Aric W. Dutelle:

> *How are photographers and the court to interpret "fair and accurate"? Fair is a relative term. The judge is tasked with making the determination of what is fair, and often this call will be based on the credibility of the witness. Even poor photographic quality will not necessarily cause an image to be inadmissible if the judge believes the image is fair and relevant to the proceedings. It should be noted that there is not a standard definition or set of parameters for the term accurate as it relates to photography in the courtroom.*
>
> *Terms such as color management, dynamic range, resolution, perspective, angle of view, or dimensionality may not be fully understood by the professional photographer or the attorney, let alone the juror. How many people can properly explain the difference between vision and perception, and articulate how this correlates to the accuracy of a photographic*

representation? It cannot be taken for granted that anyone in the courtroom understands photography on that level.

Photographers may attempt to create photographs of objects or scenes "as seen" by someone at the moment in question. Of all the purposes or goals that apply to photography, probably the most impossible is to create an image of anything exactly as another person would have seen it. It is, however, possible and much easier to make images and then use those images to help explain how it looked to you.

So in the real world, the definition of fair and accurate might be what the image is intended to show. In most cases, in order for an image to be a fair and accurate representation, it should show the questioned area or object in its most natural state. For example, if an attorney wishes to show the approximate physical or general area of involvement, then the judge may not be too strict in interpreting the term fair and accurate. In this case, a photograph of the scene would suffice for the purpose of identifying a location. On the other hand, if the primary purpose of the image is to illustrate exact details of a scene or object, such as the measured distance between two objects or the details of a latent print, then determining whether the image is fair and accurate will require much closer scrutiny.

Fair and accurate may amount to different things at different trials. It will always be a measure of the competence and credibility of the person presenting the photographs, rather than the sophistication of the camera and equipment used to create the images.

Creation of a Permanent Record

Photography is one of the four currently accepted means of providing the trier of fact (judge or jury) with visual evidence of what transpired or was present within a crime scene. Notes, Sketches, video and photographs should all support one another in regards to the documentation and preservation of evidence. Just as there are different methods whereby a student can learn a concept, some persons comprehend one documentation method more readily than they do others.

Since it is typically not possible to bring the trier of fact to the scene, it is the responsibility of those tasked with documenting the scene to bring the scene to the trier of fact. This requires that all four methods of crime scene documentation be properly undertaken in an effort to create a permanent record of the scene and its contents.

Sketches and crime scene notes are topics for other texts. Photography will be the primary topic of emphasis within this text. In order for the topic of photography to be addressed, it is necessary to begin with a discussion of the central component of photography, the camera.

Summary

For almost 150 years, photographs have been used within courts of law to give graphic representation of evidence encountered within the confines of an investigation. While photographers may attempt to create photographs of objects or scenes "as seen" by someone else, this is an impossible undertaking, as no one can accurately document an item or moment as someone else saw it. Instead, it is an appropriate step to document the image or scene from the perspective of the photographer in approximately the same position, although

not at the same moment in time. This is the challenge presented to the crime scene photographer. In order that the photographer be best prepared to confront such a challenge, it is necessary to have a general understanding of basic photography concepts, principles and methodologies. These will be the discussion of the remaining chapters.

Chapter 2

The Camera and Lens Assembly

Chapter 2: The Camera and Lens Assembly

Key Terms:

- Aperture
- Aperture Priority Mode
- Bulb Setting
- CCD
- CMOS
- DSLR
- Focal Length
- F/stop
- Glass
- Manual Mode
- Megapixel
- Shutter
- Shutter Priority Mode
- Shutter Speed
- Tripod Rule

Introduction

As was discussed in Chapter 1, to photograph something is to record or write the image using light. To do this, we make use of a camera. No matter the brand or model, the camera is used to collect and record reflected light images. Previously, this was accomplished through the use of light-sensitive film. When a photograph was taken, a chemical process was used to imprint and fix the image sent from the lens to the film at the rear of the camera body. Although there remain cameras which utilize film as a light capture device, film has largely been replaced by modern digital technology. Instead of utilizing a chemical process, data representing the image is stored in bits and bytes, onto portable memory cards or a cameras internal

memory. The greatest benefit of digital technology is its universal format, which allows for the image stored to be interpreted, viewed and shared by the majority of digital devices.

<u>Digital Single-Lens Reflex Cameras</u>

The majority of this text is dedicated to discussions associated with digital single-lens reflex cameras (referred to as digital SLR or DSLR). These cameras combine the optics and mechanisms typically present within a single-lens reflex camera with a digital imaging sensor, rather than photographic film (**Figure 2.1**).

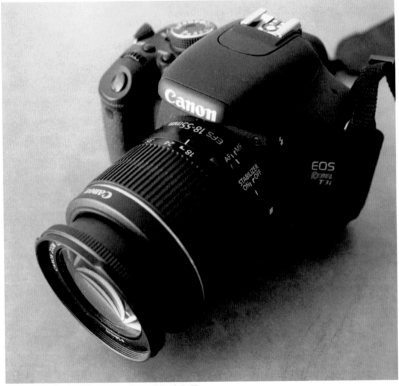

Figure 2.1: Example of DSLR camera

The primary difference between a DSLR camera and other smaller point-to-shoot digital cameras (Figure 2.2) is the "reflex" design. In a reflex designed camera body, light which travels through the camera lens strikes a mirror that alternates to send the resulting image either to the camera viewfinder or to the image sensor. By utilizing only one lens, the viewfinder presents the user with an image that will reflect almost exactly (differentiation is typically imperceptible) what is captured upon the camera's image sensor.

Figure 2.2: Example of modern point-to-shoot camera

CCD and CMOS Sensors

Today's cameras make use of digital technology, whereby the reflected light which enters the camera, is collected via a charge-coupled device (CCD) or complementary metal-oxide semiconductor (CMOS) image sensor within the camera body and the light energy is then converted into electrons, similarly to how solar cells in solar panels convert light energy for use as

a power source. CCD and CMOS sensors are typically smaller than a human fingernail. The surface of each sensor contains millions of photo cells (micro-sized diodes) that each record a single pixel of the resulting image, captured by the lens eye when the shutter is opened and closed. The greater the number of photo cells (diodes) on the sensor surface, the greater the picture quality. The **megapixel** reference used within camera specifications refers to the number of sensors on the CCD or CMOS surface. One megapixel is equal to 1 million pixels. Cameras which have higher megapixel ratings typically are capable of higher resolution photographs.

The Computer Camera

When a photograph is taken using a digital camera, there are millions of operations which occur during a very short time frame. This requires the use of an on-board computer. When the shutter release is depressed, essentially "taking" a photograph, a digital camera must then capture, interpolate, compress, filter, and store the image. The majority of cameras also allow for the captured image to be instantly previewed. This is all accomplished via an on-board computer similar in some respects to a portable laptop computer, the primary difference being that as with today's "smart" phones, the computer inside a digital camera resides on a single chip.

The camera is light-proof except for the controlled light which is allowed to strike the photo sensor. The light enters the camera body through an opening referred to as a "lens aperture". The lens collects the reflected light images to be recorded, representing the subject matter, in focus onto the photo sensor.

As discussed in Chapter 1, the primary purpose of crime scene photography is to capture a photograph which provides a true

and accurate representation of the subject matter. A crime scene photo should contain an image which is properly in-focus, is clear and accurate as to color and detail, and is void of distortion. Therefore, focus becomes an extremely important component of each photograph. The camera lens is responsible for viewing and capturing a properly focused image.

Focal Length

Camera lenses are often described in terms of their focal length (usually expressed in millimeters), such as a 15-85mm lens **(Figure 2.3)**. **Focal length**, stated simplistically, is the minimum distance (in millimeters) between the lens and the image sensor (or film plane) when the lens is focused on infinity (the farthest visible distance from the camera).

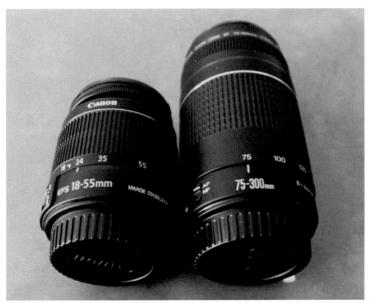

Figure 2.3: Example of modern DSLR lenses (18-55mm, 70-300mm)

In simplest terms, the focal length determines the lens angle of view, or how much the lens sees, which thus controls how much of the scene will be properly captured. The focal length also controls magnification, or how large individual elements within the resulting photograph will be. A longer focal length will result in a narrower angle of view and higher magnification, while a shorter focal length will result in a wider angle of view with lower magnification (Figure 2.4).

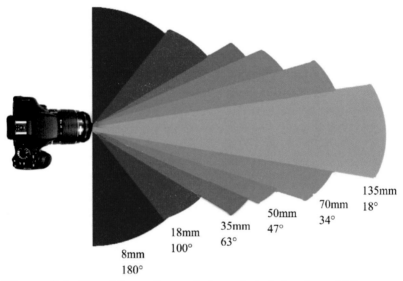

Figure 2.4: Focal Lengths and Associated Angles of View (Figure courtesy of Dana Cecil)

The Camera Lens Assembly

The modern lens is actually made up of several individual lenses which form a compound lens. Most of today's SLR and DSLR cameras provide the user with the option of changing lenses (also sometimes referred to as **glass**). This allows the user to make use of a lens which is best suited for the photographic need or environment encountered. The

interchangeability also allows for the attachment of specialized lenses, which will be discussed later **(Figure 2.5)**.

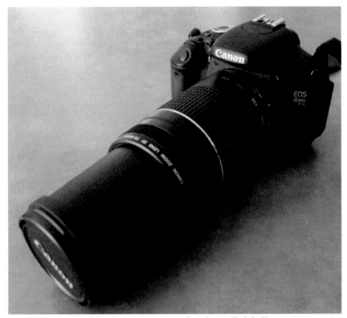

Figure 2.5: Telephoto lens attached to DSLR

SLR lenses are essentially a single-lens and therefore project the image either to the viewfinder/eyepiece or into the shutter and to the image sensor, but never to both concurrently. This is accomplished through a mirror within the camera body and a series of lenses within the lens assembly. Therefore, when a photographer makes use of the viewfinder or LCD, the image displayed has been sent through the SLR lens but not to the shutter. The light which enters the lens assembly is reflected upward via a mirror that is positioned at a 45-degree angle to the light's original path, rather than allowing it to continue forward and pass through the shutter. This reflects the light upward and onto a matte focusing screen and through a condenser lens. This lens directs the light through to a pentaprism/pentamirror, which is a mirror or prism having five

sides, in which the light is reflected off of the inner walls until it is directed to the eyepiece. Use of the pentaprism/pentamirror ensures that the resulting image is displayed properly, without being flipped upside down **(Figure 2.6)**

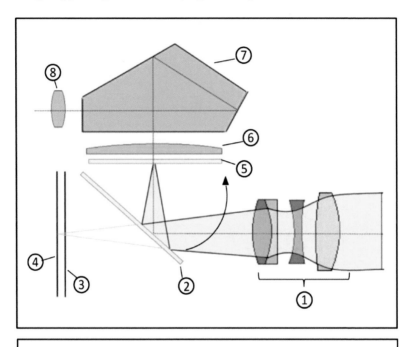

1. CAMERA LENS
2. REFLEX MIRROR
3. FOCAL-PLANE SHUTTER
4. IMAGE SENSOR
5. MATTE FOCUSING SCREEN
6. CONDENSER LENS
7. PENTAPRISM/PENTAMIRROR
8. VIEWFINDER EYEPIECE

Figure 2.6: Design of DSLR Camera and Lens Assembly
(Figure courtesy of Dana Cecil)

When the shutter release is depressed and a photograph is taken, the mirror moves up to a horizontal position as the shutter opens, thus allowing light to continue along through the shutter and be directed upon the image sensor, where it is captured as a digital photograph. However, because the image cannot be directed both at the LCD or viewfinder and the photo sensor at the same time, the eyepiece and LCD will go momentarily dark as the photograph is taken.

This explains the path that light takes when entering the lens and camera body, but how is the amount of light controlled? There are two camera components which are responsible for control of the amount of light which enters the camera body. These include the aperture and the shutter.

Aperture

Located between the front and rear lenses of the lens assembly is the **aperture**. Adjustment of the size of the aperture opening controls the amount of light entering the camera, which is directed upon the image sensor. The aperture setting (lens opening size) is referred to as the *f/stop* or *f/number*. The terms "f/stop" and "aperture" are sometimes used interchangeably, however they both refer to specific things. Aperture is the opening within the lens. *F/stop* is the size of the opening. The resulting size change of the aperture is therefore a method of exposure control, a concept which will be discussed in more depth in Chapter 3.

F/stops

Although different lenses may have different f/stops which are available, following are the whole f/stop numbers typically found on most camera lenses (**Figure 2.7**).

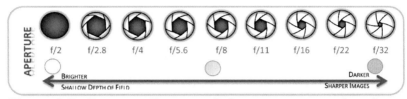

Figure 2.7: Common f/stops and the apertures produced
(Figure courtesy of Dana Cecil)

As one can see, the f/stop numbers seem a bit odd, with no apparent or logical sequence between them. However, although the f/stop numbers do not represent numerical halves or doubles of the numbers to either side they are representative of halving or doubling the amount of light being transmitted through the respective apertures. Therefore, the smaller the f/number the larger the opening for light to pass through into the camera body. Note in Figure 2.7 that f/2 is the largest opening and f/32 is the smallest opening. Increasing the opening (stopping up) will increase the amount of light permitted to enter. Decreasing the opening (stopping down) will decrease the amount of light permitted to enter.

For example, referring to Figure 2.7, if you increase the aperture opening one f/stop, from f/11 to f/8, you will double the amount of light which is permitted to enter the aperture opening.

However, if you decrease the aperture opening one f/stop, from f/5.6 down to f/8, you will decrease the amount of light permitted to enter the aperture opening by one-half.

Remember: Every time you stop up, you double the amount of light entering the lens opening. Every time you stop down, you decrease the amount of light entering the lens opening by one-half.

Shutter

The other component of the camera which controls the light permitted to enter the camera body is the **shutter**. The purpose of the shutter is to control the amount of time that the light is allowed to be focused upon the image sensor. The shutter is activated by depressing a shutter release button (or remote control in some instances).

The shutter of a DSLR camera is located directly in front of the digital image sensor. The shutter covers the sensor until the shutter release button is depressed (or a remote is activated), when it then opens for the specified amount of time (noted in seconds or fractions of a second) thus allowing light coming in through the lens aperture opening to be directed upon the image sensor. The amount of time that the shutter is permitted to be open is referred to as the **shutter speed**.

As with the aperture and associated f/stops, the shutter speed may be adjusted. Shutter speed settings, typically referred to as *exposure times*, are arranged in increments which are similar to the aperture opening sizes previously discussed. Typical shutter speed settings for modern DSLR cameras are seen below (**Figure 2.8**).

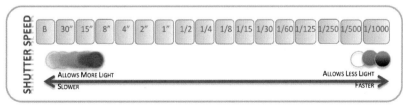

Figure 2.8: Common Shutter Speeds (Figure courtesy of Dana Cecil)

As with our discussion of aperture opening size, changing to a faster or slower shutter speed will impact the amount of light

permitted reach the light sensitive capture medium (sensor/film). For example, a 1-second exposure will allow in twice the amount of light that a ½ -second exposure will (at the same f/stop), and a 1/500 second exposure will permit half of the light that a 1/250 second exposure will (at the same f/stop).

In addition to the previously listed common exposure times, most cameras will also have the option of a *Bulb(B)* setting. Under the *Bulb* setting, the shutter will remain open for as long as the shutter release button is depressed. However, even under the steadiest of conditions, with the steadiest of hands, attempting to keep a finger depressing the shutter release button for prolonged times will result in blur from transferred vibration. In instances of excessive exposure times using the *Bulb* setting, it is suggested that an electronic shutter release cable or remote control be utilized to eliminate blur caused by camera shake.

Motion Control

Although shutter speeds are a component of exposure control (which will be discussed in greater depth in Chapter 3) they are also a means of controlling motion. Motion can be present in a number of manners. Typical motion confronted by a photographer can be characterized as either:

- Camera motion
- Subject/Content motion
- Photographer motion

Simply hand-holding a camera is enough to transfer vibration to the camera which may result in an image being blurred. Sometimes, mounting a camera to a tripod may be enough to eliminate this issue. The standard guideline (oftentimes referred to as the **Tripod Rule)** for when it is acceptable to

hand-hold a camera versus it being necessary to utilize a tripod, is to take note of the chosen focal length, turn it into a fraction, and utilize the closest shutter speed (or faster) to this fraction. For instance, when using a 75-200mm lens, with the chosen focal length being 75mm, any shutter speed slower than approximately 1/80 second will require the use of a tripod (Figure 2.9). For focal lengths shorter than 50mm, it is suggested not to hand-hold the camera. Therefore, shutter speeds slower than 1/60th of a second should make use of a tripod to reduce or eliminate blurred images.

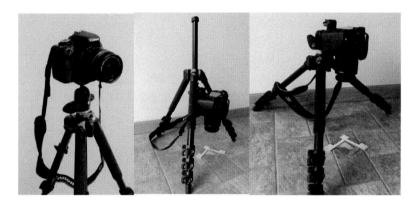

Figure 2.9: Examples of tripod use

Using Self-timer to Eliminate Camera Shake

However, in especially long shutter speed situations, even using a tripod may not be enough to eliminate blur. For this reason, it may be necessary to take control of the situation with both shutter speed and also camera system options. In this instance, it would be advisable to make use of the camera's built-in self-timer to assist with the photo capture and eliminate or reduce camera shake. For example, if a situation requires a shutter speed of ¼ second, it is suggested to use set the camera's self-timer. When the shutter release is depressed and

released, the self-timer will count down for the pre-determined amount of time (typically 3, 5 or 10 seconds) and then the camera will open and close the shutter for the pre-determined exposure time. Making use of the self-timer, along with the tripod, will allow any transferred vibration from the photographer to dissipate prior to the image being captured.

Remember: The "Tripod Rule" reminds us that when the chosen shutter speed is slower than the chosen focal length of the lens, a tripod should be used.

Stop-action Photography

Sometimes it is necessary to stop the movement of subject matter that is being photographed (Figures 2.10-2.14). In the instance of a vehicle moving or a person running, it is not possible to adequately capture the image without having the camera at the same speed as the subject, unless a fast shutter speed is used. Utilizing a fast shutter speed (1/250 and faster) will result in the subject matter appearing to freeze its motion. Clearly, the speed of the object impacts the shutter speed selection which is required to freeze the action and eliminate a blurred image.

Figure 2.10: Shutter speed of 1/60
Figure 2.11: Shutter speed of 1/100
Figure 2.12: Shutter speed of 1/250
Figure 2.13: Shutter speed of 1/500
Figure 2.14: Shutter speed of 1/1000

Figure 2.10 Figure 2.11

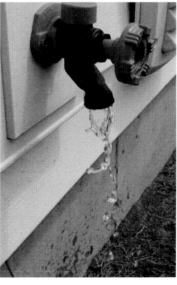

Figure 2.12 Figure 2.13

Figure 2.14

Commonly used shutter speeds for commonly encountered situations are shown below:

- 1/60 second is the slowest recommended speed for hand-holding a camera while photographing an unmoving item of evidence.
- 1/250 second is the slowest recommended speed for stopping/freezing a jogger or bicyclist.
- 1/500 second is the slowest recommended speed for stopping/freezing a vehicle moving approximately 30mph.
- 1/1000 second is the slowest recommended speed for stopping/freezing a vehicle moving approximately 60mph.

Remember: The preferred shutter speed for most hand-held images is 1/60 second.

Panning

As one can see from the examples provided, if a photographer attempts to stop the action of a subject with too slow of a shutter speed, the subject appears blurred, however the background will appear in focus. Since the background is not the intended subject matter, but rather the object which is exerting movement, there remains another option for attempting to freeze the action. Due to lighting conditions and exposure concerns, it may not always be possible to utilize a fast shutter speed. In such an instance it may be possible for the photographer to utilize a **panning** technique in order to stop the action and capture a properly exposed photo as well.

With panning, the photographer uses a tripod and positions themselves perpendicular to the motion, with the moving subject moving from either left or right or right to left across the viewing plane. Rather than tighten the camera on the tripod, the head of the tripod should remain untightened, with the ability to move the camera smoothly from right to left (or left to right). The photographer should then meter for the specific exposure settings required and if a slower shutter speed is necessary, they should feel free to set the slower shutter speed and instead of keeping the camera motionless and capturing the intended image, the photographer will follow the movement of the subject with the camera.

The photographer should pick up the moving subject outside the intended area of photography and follow the movement with a fluid motion, taking the photograph at the intended point when the subject is directly in front of the camera (as it would appear if it were a non-moving object) and continue following the subject motion after depressing the shutter release. This is similar to following through while shooting a basketball or while trap or target shooting. Failure to continue to follow the

action and have the event be a fluid movement of camera aimed at subject, may result in subject blur. However, when properly used, the subject matter will appear sharp and in-focus, whereas the background will be blurred, which should not be an issue since the background was likely not the intended subject of the photograph (Figure 2.15).

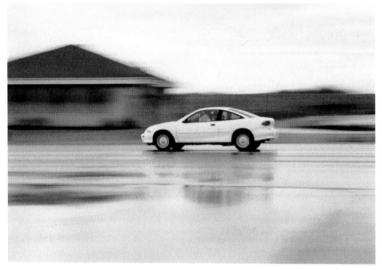

Figure 2.15: Capturing a moving subject using panning technique (1/30 shutter speed)

Taking Manual Control

While today's cameras are infinitely "smarter" than cameras of yesteryear, it will sometimes be necessary for the photographer to take manual control over camera settings in order to best capture the confronted subject matter. Manual control operations can be grouped into two primary areas, exposure and focus. Exposure is the topic of discussion within Chapter 3, while focus and depth of field are the topic of discussion within Chapter 4. For now, having already discussed shutter speeds and aperture settings within the confines of this chapter, let us

look at how to take manual control over these two settings and when it is appropriate to do so.

Shutter Priority Mode

All DSLRs on the market will give the photographer the option of taking full manual control over the shutter speed setting and will in turn assist the photographer by having the camera select the appropriate aperture setting which would result in a properly exposed photograph under the selected shutter speed. This is referred to as **shutter priority mode** (referred to as "time value" mode by some manufacturers). This mode is especially useful for taking stop-action photographs where the photographer is confronted with a scenario whereby the photographer, camera, or subject matter is moving. In any of these scenarios, if the photographer was to choose shutter priority mode, he or she could choose a shutter speed which would be appropriate to stop the action or movement and the camera will in-turn choose the proper aperture setting which will result in a properly exposed photograph.

Aperture Priority Mode

Chapter 4 will concentrate on establishing proper depth of field and focused subject matter, for now it will suffice to discuss that at times it is beneficial to the photographer to take control of the aperture setting of the camera as a priority and have the camera choose the resulting appropriate shutter speed which will ensure a properly exposed image. This is referred to as **aperture priority mode**. A small f/number (f/5.6) will result in relatively little of the image from the photographer to the object of interest and beyond being in focus, whereas a higher f/number (f/32) will result in the greatest amount of subject matter appearing within sharp focus. This will be discussed in greater depth within Chapter 4.

Full Manual Mode

Sometimes, it will be necessary for the photographer to take complete control over the shutter speed and aperture settings for the camera. This will be the case in difficult photography conditions such as extremely low light, high contrast and in some macro-photography settings. In **manual mode** the photographer is responsible for choosing both the shutter speed and corresponding aperture setting which will result in a properly exposed image. The camera will not choose either setting and will allow the photograph to be taken regardless of whether or not the resulting image is over or underexposed.

Manual Focus

The majority of the time, the photographer will likely find that auto focus will be sufficient to meet encountered needs. However, sometimes it will become necessary for the photographer to take manual control over focus of the confronted subject matter. An example of this would be the photographer who is attempting to shoot photographs within a fire or crime scene which involves steam, vehicle or pedestrian traffic between the photographer and the subject matter, or a situation whereby a fence, screen, window, tree branches or other items are between the photographer and the intended subject matter. In these cases, leaving the camera on auto-focus could result in the camera "choosing" the wrong subject matter upon which to focus, thus resulting in the intended subject matter not being displayed in proper focus (**Figure 2.16**). In these cases, it would be most beneficial if the photographer were to switch to manual focus in order to manually take control over what the camera will be capturing as in or out of focus (**Figure 2.17**).

Remember: Under the manual focus setting, the camera will rely upon the photographer to take control of and focus the camera lens so as to result in a captured image which is in focus. It will take the photograph regardless of whether or not an image is in focus.

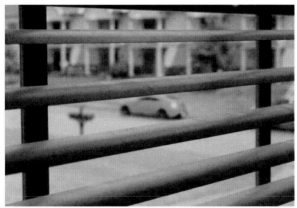

Figure 2.16: Attempting to use auto-focus

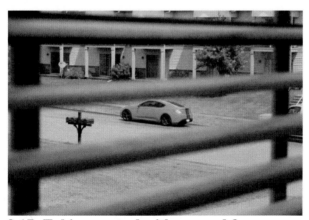

Figure 2.17: Taking control with manual focus

42

Summary

The modern DSLR is capable of some amazing things when placed in capable hands coupled with a knowledgeable mind. However, although modern cameras are filled with automatic and pre-programmed settings, it is sometimes necessary for the photographer to take manual control over one or more settings in order to properly capture an image. For this reason, a basic understanding of the photographic principles and various camera controls is required. At the very least, a glance at the camera owner's manual is strongly suggested.

Application of Chapter Concepts

1. In daylight, take four photographs of a vehicle that is moving at a speed of 30 mph or faster. The vehicle should be moving across the picture area versus moving toward or away from the camera. Get close enough to fill about half the view finder with the subject. Use the meter in the camera to adjust the f-stop between photographs to ensure good exposures.
 a. Use a fast shutter speed (1/500 or faster)
 b. Use a medium shutter speed (1/60 or 1/125)
 c. Use a slow shutter speed (1/30 or slower)
 d. Use a slow shutter speed (1/30 or slower) and use the panning technique.

2. Take two photographs inside in low light using a shutter speed of 1/15 or slower. Use the meter to adjust the f-stop to ensure good exposures.
 a. Hand hold the camera
 b. Put the camera on a tripod

Chapter 3

Exposure

Chapter 3: Exposure

Key Terms:

- Bracket
- Digital White Balance
- Exposure Stops
- Exposure Triangle
- ISO
- Metering
- Noise
- Overexposed
- Reciprocal Exposures
- Underexposed

Introduction

Images produced as a result of the photographic process can be considered to be properly exposed, underexposed, or overexposed. Images which have insufficient lighting and are darker than they should be are referred to as **underexposed (Figure 3.1)**, whereas images which have too much light and tend to be washed out are referred to as **overexposed (Figure 3.3)**. A properly exposed photograph should be true as to lighting, color and detail (Figure 3.2). Over or underexposure occurs for a number of reasons but is typically due to insufficient (underexposed) or too much (overexposed) light being directed upon the image sensor (CCD/CMOS).

Figure 3.1: Underexposed image

Figure 3.2: Properly exposed image

Figure 3.3: Overexposed image

Metering

In order to gauge what is required to ensure a properly exposed image, it is necessary for the photographer to **meter** the intended subject matter prior to taking the photograph. This is an evaluative process which is accomplished by depressing the shutter-release half way. The camera will emit infra-red beams which will gauge the available lighting of the subject matter and "suggest" proper exposure settings to the photographer. There are several meter setting options available to the photographer, depending upon the DSLR system he or she is using. The most common are discussed below.

Evaluative Metering

When the camera is under this setting, the camera will automatically set the exposure so as best to suit the scene. This is typically the default setting and the setting most appropriate for photographers unfamiliar with the metering process. With

evaluative metering, the exposure setting will be locked when the shutter button is depressed halfway and focus is achieved (if auto-focused). (Figure 3.4)

Figure 3.4: Example of evaluative metering related to field of view

Partial Metering

This setting is most effective when there is background present which is much brighter than the subject matter due to backlighting, etc. Under this setting, the photographer defines the area of the field of view that he or she wishes the camera to meter to obtain the standard exposure setting. The exposure setting is set at the moment of exposure and is not locked by depressing the shutter button halfway. (Figure 3.5)

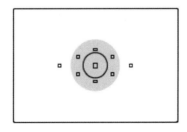

Figure 3.5: Example of partial metering related to field of view

48

Spot Metering

This mode is used for metering a specific part of the intended subject or scene. The shaded area in **Figure 3.6** indicates where the brightness is metered to obtain the standard exposure. The exposure setting is set at the moment of exposure and is not locked by depressing the shutter button halfway. This mode is suggested for advanced users.

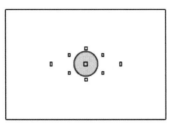

Figure 3.6: Example of spot metering related to field of view

Center-weighted Average Metering

In this setting, brightness is metered at the center of the subject matter and is then averaged for the entire viewing area. The exposure setting is set at the moment of exposure and is not locked by depressing the shutter button halfway. This mode is suggested for advanced users (**Figure 3.7**).

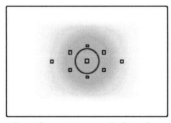

Figure 3.7: Example of center-weighted average metering related to field of view

However, although the majority of time a photographer is seeking a properly exposed photograph, sometimes it may be necessary to intentionally under or overexpose an image. This is referred to as bracketing.

Bracketing

When a photographer **brackets** an image it means that after what the photographer considers to be a properly exposed photograph is taken, then he/she will take several additional photos from the same vantage point, of the same subject matter, slightly over and slightly underexposed.

There are typically two main reasons for conducting bracketing while engaged in crime scene photography.

- Difficult/Problematic lighting conditions
- Close-up/Examination/Detailed photographs

As with all photos taken during crime scene photography, the images should be true and accurate as to how the subject matter appeared to the eye of the observer. However, in some cases there may be difficult or challenging lighting conditions present which will give the subject matter incorrect coloration or shadows. (Lighting and lighting conditions will be discussed in more detail later). While an image may be taken that the photographer considers "properly exposed" it is often good practice to take several additional photos which over and underexpose the subject matter. Since it is often impossible, impractical, or illegal to come back to a scene and re-shoot photographs, it is wise to take the photos when there is opportunity to do so.

In the case of close-up/examination/detailed photographs, it is a wise practice to bracket images to assist the forensic

examiner with eventual identification/analysis of the item being photographed. For instance, if a photographer is attempting to capture an image of a fingerprint depressed into wax, the photographer will likely take a very close-up photograph of the print in a manner which he or she considers to be properly exposed. They should then continue to take additional photographs of the print from the same vantage point, with different lighting conditions (darker and lighter). This should be done because a print left in wax is a three-dimensional impression and the shadows created by the indentations of the friction ridge skin of the finger may assist with the eventual examination and identification of the print. The more photographs which are taken, which show various areas of detail with differing lighting conditions, the better the chance for the eventual identification. This is true for footwear impressions, bitemarks, toolmarks, and many other types of physical evidence which are encountered during crime scene photography. The important part is to ensure there is at least one photograph which is true and accurate as to what the photographer observed when they were capturing the image. The remaining photographs are taken to assist with the identification process, rather than be reflective of the trueness of the image to its condition at the time that the image was taken.

Exposure Triangle

There are four variables associated with a properly exposed photograph. These include:

- f/stop
- shutter speed
- ISO setting
- Lighting (available or supplemental)

If there is a change in any of these variables, the resulting images exposure will be changed. Due to their inter-relatedness, the four variables are often displayed in a graphical representation known as the **exposure triangle (Figure 3.8)**, as seen below.

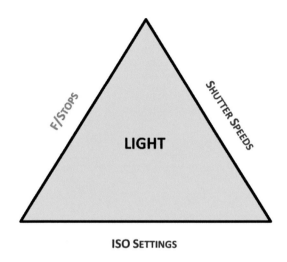

ISO Settings

Figure 3.8: Exposure Triangle (Figure courtesy of Dana Cecil)

Shutter speeds and f/stops have been adequately covered to this point (Chapter 2) and they will be continued to be discussed throughout the text. However, the remaining side of the exposure triangle (ISO) and the central area (lighting) have yet to be addressed.

ISO

When film was utilized for cameras, photographers would choose their film based upon ISO or ASA speeds. These were film ratings assigned by the International Standards Organization (ISO) and American Standards Association (ASA). The ratings indicated the specific film type's relative

sensitivity to light. A low number (100) meant that the film was not as sensitive to light and could be used in bright conditions. A higher number (1600) was much more sensitive to light and thus was used within darker conditions. Today, although film is not typically used, ISO is still an acronym commonly associated with the photographic process (ASA has since given way to ISO and is no longer referenced). Common ISO speeds found in the majority of modern DSLR cameras are found in **Figure 3.9.**

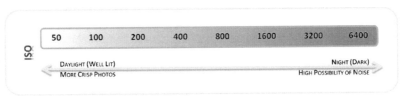

Figure 3.9: Common ISO speeds (Figure courtesy of Dana Cecil)

However, with film there was a drawback to faster speed films. As film speed increased, and film became more sensitive to light, there was an increase in graininess of the image. In today's terminology, it is similar to the image becoming "pixelated". Digital ISO equivalents have similar drawbacks where higher speeds are concerned, but the graininess is referred to as **noise**, and it is typically found in dark images as lighter, pixelated sections. While ISO settings and principles remain similar between the film cameras of old and today's DSLR cameras, the benefit of today's technology is that ISO settings can be changed with each and every photograph taken, versus having to shoot an entire roll of film under the same film ISO speed (**Figures 3.10-3.13**). This holds tremendous benefit when shooting in the complex and dynamic conditions often confronted in crime scene photography.

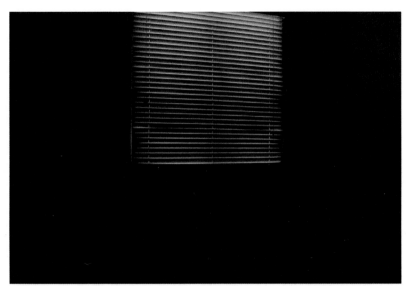

Figure 3.10: Photograph of subject using ISO 100 (Photo courtesy of Dana Cecil)

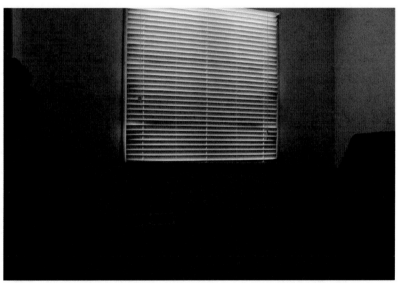

Figure 3.11: Photograph of subject using ISO 200 (Photo courtesy of Dana Cecil)

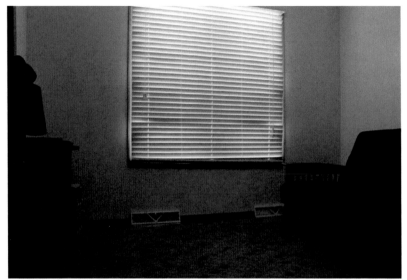

Figure 3.12: Photograph of subject using ISO 400 (Photo courtesy of Dana Cecil)

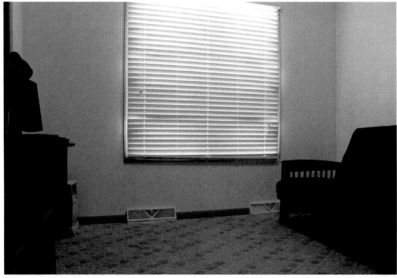

Figure 3.12: Photograph of subject using ISO 800 (Photo courtesy of Dana Cecil)

White Balance

Today's DSLR cameras have an added feature which further assists with proper image exposure. **Digital white balance** is a feature which allows the photographer the ability to program the camera to correspond to the correct available lighting conditions present at the scene. The camera will then adjust the resulting image colors, based around the "color" white, so that they are correct. Typical camera presents for white balance settings are seen in Figure 3.14. If auto white balance (AWB) is used, then the camera attempts to automatically adjust image colors based upon an object which the camera identifies as being "white" within the imaged area.

AWB AUTO

DAYLIGHT

CLOUDY

SHADE

TUNGSTEN

FLUORESCENT

FLASH

CUSTOM

Figure 3.14: Typical Digital White Balance Options

It is important for the photographer to be aware of the lighting conditions which surround the intended subject matter. Failure to properly balance for the dominant light color can impact what the camera determines to be "white". Following, are examples of the same scene exposed under various white balance settings.

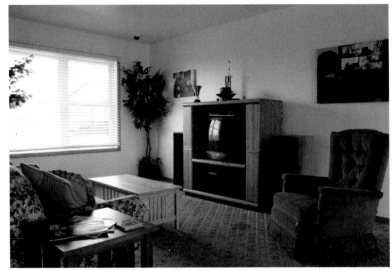

Figure 3.15: Photo taken with white balance set for "daylight" (Photo courtesy of Dana Cecil)

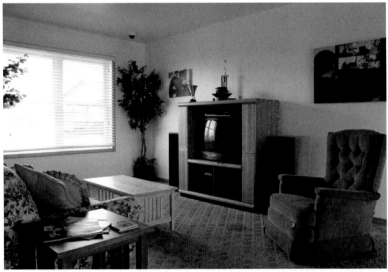

Figure 3.16: Photo taken with white balance set for "shade" (Photo courtesy of Dana Cecil)

57

Figure 3.17: Photo taken with white balance set for "cloudy" (Photo courtesy of Dana Cecil)

Figure 3.18: Photo taken with white balance set for "tungsten" (bulb type) (Photo courtesy of Dana Cecil)

Figure 3.19: Photo taken with white balance set for "fluorescent" (bulb type) (Photo courtesy of Dana Cecil)

Figure 3.20: Photo taken with white balance set for "flash" (Photo courtesy of Dana Cecil)

Exposure Stops

Making proper use of the exposure triangle should result in a
properly exposed photograph. However, if the photographer
should choose to intentionally alter the image exposure (as in
the case of bracketing) it is possible for he or she to do so
within precise boundaries. This is done through using
exposure stops or exposure values (EV +/-). These can be
accomplished by adjusting the aperture or using the EV setting
available on many modern DSLRs. Exposure stops are precise
boundaries which refer to a measured over or underexposure. If
a photographer chooses to overexpose the properly exposed
image by one exposure stop (+1) they will be doubling the
amount of light which will be captured within the resulting
image. Conversely, if a photographer chooses to underexpose
the properly exposed image by one exposure stop (-1) they will
be halving the amount of light which will be captured within
the resulting image **(Figure 3.21)**. This is referred to as
"stopping up" or "stopping down".

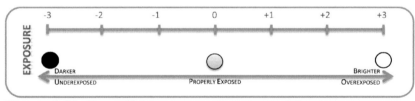

Figure 3.21: Establishing proper exposure (Figure courtesy
of Dana Cecil)

Reciprocal Exposures

Capturing a properly exposed image is the ultimate goal in
most cases of crime scene photography. However, since there
are a number of different factors in play which impact proper

exposure, there is the possibility of having several camera settings which will result in the same image exposure.

For instance, during our discussion of shutter speeds, it was discussed that stopping up (+1) would result in doubling the available light, while stopping down would halve the available light. The same was true for aperture settings. Stopping up with shutter speed (+1) is balanced by stopping down aperture setting (-1).

Therefore, if a properly exposed image called for an aperture setting of f/5.6 and a shutter speed of 1/30 second, there are **reciprocal exposures** which exist which would result in the same image being properly exposed. The photographer has the option of changing the shutter speed to 1/60 second (+1), which would necessitate changing the aperture to f/4. This would result in the same amount of light being directed upon the image sensor, resulting in the same image exposure.

If the photographer wishes to slow the shutter speed down rather than speed it up, he or she could stop down the shutter speed to 1/15 second (-1) and then stop up the aperture setting to f/8 (+1). Again, this would result in the same image exposure as the originally photographed image. **Figure 3.22** shows examples of reciprocal exposure settings which would result in the same image exposure.

So, if they result in the same image exposure, some may ask "well, then does it matter?" Yes, it certainly does. The photographer is presented with the various options because there is more than proper exposure to be thought of. One must also consider how far one is from the subject matter, where the camera is to be focused, and environmental challenges which are present. These will all be discussed in forthcoming

chapters. For now, knowing that reciprocal exposure possibilities exist will suffice.

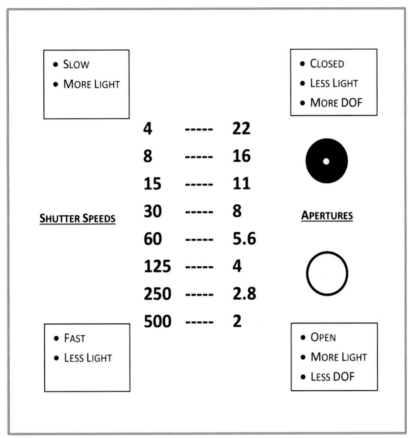

Figure 3.22: Reciprocal Exposures (Figure courtesy of Dana Cecil)

<u>Summary</u>

As discussed within this chapter, properly exposing an image is a combination of a number of factors. The photographer must consider lighting, color, and associated camera settings in order

to ensure that the resulting image is one that accurately reflects the reality that was viewed by the photographer's eyes.

Next to properly exposing an image, ensuring that the intended subject matter is in proper focus, is probably the second most challenging and encountered photography issue. To ensure that the intended subject matter is represented in proper focus, the photographer must consider depth of field. This will be discussed in-depth within Chapter 4.

Application of Chapter Concepts

1. Take three photographs of a daylight (sun or shade) scene at different exposures.
 a. Expose the scene properly
 b. Underexpose the scene by 2 stops (Change either the f-stop OR shutter speed to let in less light)
 c. Overexpose the scene by 2 stops (Start with the "good" exposure, then either move the f-stop twice to a larger one, OR move the shutter speed twice to a slower one)

2. Take three photographs of an indoor scene (low light) at different exposures without using a flash. Make sure the scene is fairly evenly lit. A tripod may be used.
 a. Expose the scene properly
 b. Underexpose the scene by 2 stops
 c. Overexpose the scene by 2 stops

3. Take three photographs of a backlit subject. The subject should be in shade (relatively dark) and the background should be well lit (quite a bit brighter than the subject). Place the subject 7 to 10 feet from the camera.
 a. Using the meter normally, set the camera for the overall exposure of the scene and take a photo. (Do

not use a flash.)

 b. Approach the subject and take a meter reading with the subject filling the view finder. Set the camera for that exposure, move back to your original position and take a photo. (Do not use a flash.)

 c. Meter for the overall scene and take a photo using flash.

4. Take a series of indoor photos, changing the white balance setting for each.

 a. Photo taken with white balance set for "daylight"

 b. Photo taken with white balance set for "flash".

 c. Photo taken with white balance set for "fluorescent" (bulb type).

 d. Photo taken with white balance set for "tungsten" (bulb type).

5. Take a series of outdoor photos, changing the white balance setting for each.

 a. Photo taken with white balance set for "daylight"

 b. Photo taken with white balance set for "flash".

 c. Photo taken with white balance set for "fluorescent" (bulb type).

 d. Photo taken with white balance set for "tungsten" (bulb type).

Chapter 4

Depth of Field

Chapter 4: Depth of Field

Key Terms:

- Aperture priority mode
- Deep DOF
- Depth of field
- Shallow DOF

Introduction

As discussed within Chapters 2 and 3, the correct combination of both shutter speed and aperture setting will result in proper exposure of the intended image. However, the same combination also has an influence on what portion of the resulting image appears in focus. The portion of the resulting photograph, from foreground to the background, which is represented in sharpest focus, is referred to as the images **depth of field (DOF)**.

A photograph which exhibits very little of the subject matter to be in-focus is said to have a **shallow DOF (Figure 4.1)**, whereas a photograph which has the majority of the photograph in-focus is said to have a **deep DOF (Figure 4.2)**.

Typically, in crime scene photography, DOF is controlled through the photographer's choice of aperture setting. With all other variables remaining the same, the smaller the aperture opening (IE: f/32), the greater the resulting DOF exhibited within the image **(Figure 4.2)**. On the contrary, the larger the aperture opening (IE: f/2), the smaller the resulting DOF exhibited within the image **(Figure 4.1)**.

66

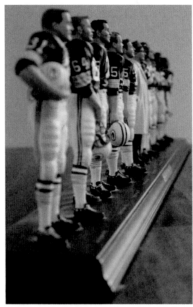

Figure 4.1: Example of shallow depth of field (f/2)

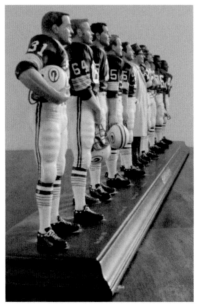

Figure 4.2: Example of deep depth of field (f/32)

There are two additional factors which contribute to defining depth of field. These include the focal length of the lens selected as well as the distance of the subject matter from the lens or the distance of the point of focus from the camera.

Wide-angle lenses have a wide DOF therefore it is not necessary to set a high aperture number in order to obtain a sharp image from the foreground to the background. However, a telephoto lens has a narrow DOF, thus higher aperture numbers are necessary in order to obtain a sharp image.

The closer a subject is to the camera, the narrower the resulting DOF. However, a subject further from the camera will have a wider DOF.

Remember: Depth of field is determined by three things:

- *Size of the aperture*
- *Focal length of the lens*
- *Distance of the subject from the lens, or point of focus*

Depth of Field Preview

Since the aperture opening changes only at the precise moment when the photograph is taken, many of the DSLRs on the market today will give the photographer the ability to preview the resulting image DOF in advance by simply pressing a button on the camera body. This is especially important since many photographers today make use of the LCD to compose their photos. In doing so, it must be remembered that the aperture remains fully open until the photo is taken. Therefore, in order to see what the chosen or intended DOF will be, it will be necessary for the photographer to press the DOF preview button so that he or she is able to determine if the

predetermined DOF is sufficient, prior to actually taking the photograph.

Aperture Priority

As was mentioned in Chapter 2, at times it is beneficial to the photographer to take control of the aperture setting of the camera as a priority and have the camera choose the resulting appropriate shutter speed which will ensure a properly exposed image. This is referred to as **aperture priority mode**. A small f/number (f/5/6) will result in relatively little of the image being in focus, whereas a higher f/number (f/32) will result in the greatest amount of subject matter appearing within sharp focus.

Selecting DOF

Crime scene and evidence images should include the maximum amount of the subject matter to be in-focus, in most instances. However, in some instances, it may be necessary to limit or select the subject matter which is in focus. In instances where an object is curved (such as a door handle or beverage container) and there is a fingerprint present upon the curved surface, it will be necessary to limit the DOF so as to include the subject matter (fingerprint) and not include the distracting foreground and background matter (Figure 4.3). Another example could be when conducting overall photos or surveillance photographs taken through a horizontal window shade. It would be best to limit the DOF in this case so that the foreground (window treatment) is out of focus and barely visible (Figure 4.4).

Remember: The ultimate purpose of crime scene photography is to capture a fair and accurate representation of the subject matter. However, the photographer should do so in a manner

which is least distracting to the eventual viewer of the photograph. Therefore, in limited situations, narrowing DOF may assist in eliminating distracting elements and focusing attention upon the intended subject matter.

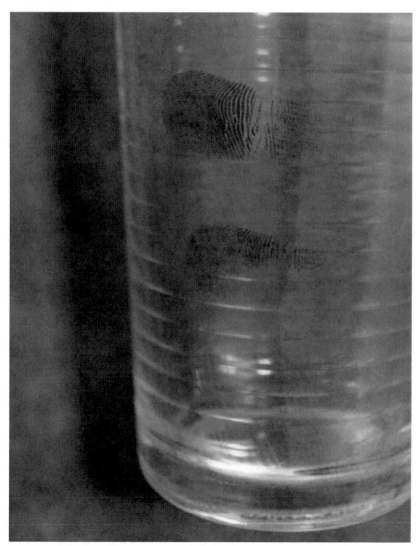

Figure 4.3: Shallow depth of field isolating evidence

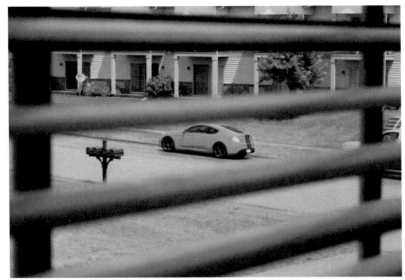

Figure 4.4: Shallow depth of field blurring foreground to reduce focus on window shade.

Summary

Proper utilization of depth of field is one of the most misunderstood and misused concepts in crime scene photography. The majority of time, depth of field should be maximized when documenting evidence and conditions at a crime scene. Minimizing depth of field is done only in limited situations when it is important to isolate or draw attention to specific details or evidence. In addition to DOF, there are other factors and photographer decisions which can assist with properly documenting and focusing attention on specific subject matters. These will be the topic of discussion for Chapter 5.

Application of Chapter Concepts

1. In daylight, take three photographs, each showing three objects. The camera should be on a tripod, and not moved for this assignment Place one object two feet away from the camera, the second object four feet away from the camera, and the third one seven feet away from the camera. Focus on the middle object. Use the meter to adjust the shutter speed between exposures to maintain good exposures.

 a. Use a small f/stop (f/22)
 b. Use a medium f/stop (f/8)
 c. Use a large f/stop (f/2)

2. Repeat the last assignment, placing the objects five feet, ten feet and twenty feet away from the camera. Use the meter to adjust the shutter speed between exposures to maintain good exposures.

 a. Use a small f/stop (f/22)
 b. Use a medium f/stop (f/8)
 c. Use a large f/stop (f/2)

3. Place a fingerprint on a curved surface (drinking glass or door handle) and attempt to use various f/stops to properly photograph the print. A tripod will be necessary for this exercise.

Chapter 5

The Image

Chapter 5: The Image

Key Terms:

- Composition
- GIF
- Horizontal composition
- JPEG
- Lossless compression
- Lossy compression
- Raw
- Resolution
- SWGFAST
- SWGIT
- SWGTREAD
- TIFF
- Vertical composition

Introduction

To this point, the concepts and features involved with taking a fair and accurate photograph have been discussed. What has been missing to this point is a discussion of what actually makes up an image. It is not enough to know that there are three things that impact depth of field, or know what results in a properly exposed image. The photographer must also take into account that he or she is taking the photograph properly so as to best capture the intent and purpose behind the resulting image. This is referred to as composition.

Composition

Composition is consciously selecting the subject matter which appears within the field of view in a manner which contributes

to image value rather than distracting from it. When one takes photographs of landscape or family activities for hobby purposes, there is different intent and purpose behind the photography efforts. The images which are taken during crime scene photography efforts should not be randomly or haphazardly taken. Each image must be a conscious effort to capture the intended subject matter and details which are present, in the most appropriate and accurate manner.

The photographer must be responsible for everything which appears within the captured image, as well as responsible for everything which does not. Therefore, anything which is present within the image should be present because the photographer intended for the content to be present.

Filling the Frame

It is the photographer's responsibility to fill the frame with the intended subject matter and accompanying details. To do so, the photographer must choose the most appropriate viewpoint and viewing angle to capture the intended elements of the image. The photographer should take into account clutter and distracting elements within the subject surroundings, as well as lighting conditions and other photographic elements when composing the image. When the viewpoint and viewing angle are chosen, then intended subject matter should then be photographed in such a way that they fill the field of view within the resulting image (Figures 5.1-5.5). Figure 5.1 would most appropriately be classified as a mid-range photograph however it contains distracting elements which are not necessary to orient the viewer to the intended subject matter. Figure 5.2 is more appropriate as a mid-range. Figure 5.3

would be inappropriate both as a mid-range and as a close-up since it does not either orient the viewer to the items

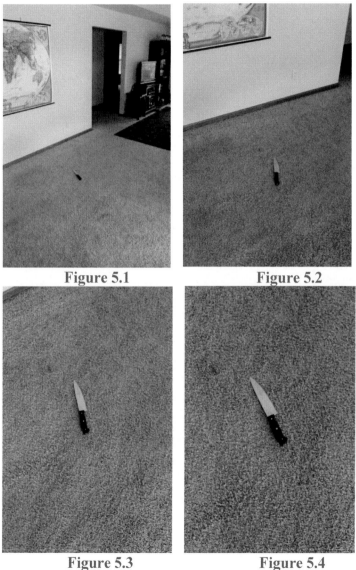

Figure 5.1 Figure 5.2

Figure 5.3 Figure 5.4
Subject matter incorrectly filling the frame

Figure 5.5: Subject matter correctly filling the frame

surroundings, nor does it fill the frame with the subject matter is would be appropriate within a close up. Figure 5.4 does not fill the frame.

Size and orientation of the intended subject matter also should be considered by the photographer when composing the image. This means that the photographer must choose whether to have the camera oriented in a vertical or horizontal manner in order to properly capture the image either in a vertical or horizontal composition. In **vertical composition**, the image is oriented top to bottom or length-wise, with the image necessitating the photographer to turn the camera sideways in order to properly capture the image. In **horizontal composition**, the image is oriented from side-to-side, right to left, or left to right, necessitating that the photographer hold the camera in the customary manner in order to properly capture the intended subject matter (Figure 5.6-5.11).

Figure 5.6 Figure 5.7

Figure 5.8
Examples of improperly composed images (Photos courtesy of Dana Cecil)

Figure 5.9

Figure 5.10 **Figure 5.11**

Examples of properly composed images (Photos courtesy of Dana Cecil)

To Zoom or not to Zoom?

Since the human eye is not capable of zooming, the photographer should make a concerted effort to only zoom closer to an item in a couple of instances. These include:

- If it is unsafe to get closer to the intended subject matter.
- If it is impossible to get closer to the intended subject matter.
- When photographing close-up/detailed/examination photographs.

Eliminate Distractions

It is equally important that the photographer eliminate any items or details which may detract from the overall purpose of the photograph. This is not to say that the photographer should intentionally overlook, fail to document or hide items or details. Rather, it is important for the photographer to keep in mind the intent behind a given image and not attempt to capture too much with only one photograph. There are many different photographic ranges and perspectives which are important and pertinent to a given scenario (discussed in Chapter 6), and it is impossible to cover everything with only a single image. An image will have the greatest value if there is a single purpose behind the photograph. Properly eliminating distractions or superfluous elements from the field of view will add to the value of the image.

Remember: Composition includes:

- *Choosing the photographers viewpoint/viewing angle*
- *Choosing which elements are included as subject matter*
- *Choosing which elements are excluded as subject matter*
- *Filling the frame with the intended subject matter*

Image Resolution

How clear a resulting image appears is not entirely dependent upon focus. The term "in-focus" is often confused with the term "resolution."

The term **resolution** means the ability to resolve, or distinguish, parallel black and white line pairs as individual lines. When the black and white alternating lines become thinner and closer together, there will reach a point when they are indistinguishable as separate lines and will instead appear as an area of gray. However, with higher resolution (higher megapixels) the individuality of the lines is able to be determined for a greater distance. Therefore, with greater resolution, there is greater ability to distinguish detail.

The **megapixel** reference used within camera specifications refers to the number of sensors on the CCD or CMOS surface. One megapixel is equal to 1 million pixels. Cameras which have higher megapixel ratings typically are capable of higher resolution photographs.

How much is enough?

Where crime scene photography is concerned there are well defined standards for digital photography equipment which is to be used for crime scene documentation.

The Scientific Working Group on Imaging Technologies (SWGIT) suggests that crime scene photographers should use a minimum of a 6MP camera to document crime scenes.

The Scientific Working Group for Shoeprint and Tire Tread Evidence (SWGTREAD) suggests that shoe prints and tire tracks be photographed by at least an 8MP camera.

The Scientific Working Group on Friction Ridge Analysis, Study, and Technology (SWGFAST) suggests that fingerprints and palm prints should be photographed using a resolution which results in a minimum of 1000 ppi across the subject matter area.

Anything less than the above suggested resolutions is risking the resulting images being captured with inadequate clarity and sharpness which will make it more difficult for forensic experts to compare the images against known fingerprints, tires or shoes.

Image Format

Compression of an image, the process of reducing the size of an image data file resulting in less required storage space, is one solution, but it has a downside. The problem being that when an image is saved to a camera's internal memory or memory capture/ storage device and also when it is

subsequently saved to an agency's digital storage system, the image may be saved in a compressed format. Compression of an image is considered a form of alteration, and any alteration may be argued as distorting the accuracy of the image.

There are two methods for compression, lossless and lossy compression.

Lossless compression is that which reduces the file size by removing redundant data. This data can be subsequently retrieved during reconstruction of the image for display, therefore lossless compression results in virtually no loss of information. (Graphical Interchange Format, GIF, would be an example of such a file format).

Lossy compression is the other method for compression. This method involves even greater compression and reduction in file size, achieving this through the removal of both redundant and extraneous information. The extraneous or irrelevant information cannot be subsequently retrieved during reconstruction for display purposes, and is thus lost. Therefore, this method is inappropriate for criminal justice purposes from a chain of custody standpoint. (Joint Photographic Experts Group, JPEG, would be an example of such a file format).

Some camera manufacturers now offer a read-only **Raw** file format. The benefit of these files is that they are virtually unalterable, which is an advantage for archival and chain of custody purposes. These files are the digital equivalent of negatives, in that the digital negative is not directly usable as an image, but it contains all of the information needed to create an image. The Raw file format is the preferred file format for

digital images, due to its unaltered format. However, this format does come with a few disadvantages:

> -These are usually a proprietary file format, which might make subsequent display of images impossible if not in possession of proprietary software.
>
> - A Raw file format is a large file, and requires a great deal of data storage space.

Some cameras will allow the photographer to simultaneously capture all images in both a Raw and JPEG file format.

The uncompressed Tagged Image File Format (TIFF) is the next best alternative to the Raw file format in terms of quality. This is still a very large file size, however is not proprietary and is able to be displayed without possession of proprietary software.

JPEG is the least desirable, but still acceptable format, within forensic laboratories. BMP formats are almost entirely unacceptable for forensic or criminal justice purposes.

Summary

In addition to the technical aspects of exposure and camera control, there are other components which must be considered and incorporated in order that a successful and proper image is obtained. Subject matter composition, image resolution, and image file type all play a part in the successful imaging of a crime scene. Failure to consider all aspects could result in an other than fair and accurate representation of the intended subject matter and thus possibly be inadmissible within a court,

or at the very least, be of no use or benefit within the investigative process.

Application of Chapter Concepts

1. Indoors, where lighting and camera location remain the same, photograph a scene under various formats and resolution.
 a. Photograph the scene using a small (minimum) file size
 b. Photograph the scene using a medium file size
 c. Photograph the scene using a large (maximum) file size

2. Save a photograph in each of the following formats: BMP, TIFF and JPEG. Attempt to enlarge each to various standard sizes (5x7, 8x10, etc.) Note resolution present within each.

Chapter 6

Lighting

Chapter 6: Lighting

Key Terms:

- Alternate Light Source (ALS)
- Barrier Filter
- Bounce Flash
- Diffused Light
- Electronic Flash Unit (EFU)
- Hard Light
- Inverse Square Law
- Oblique lighting
- Painting with Light
- Red-Eye
- Soft Light

Introduction

The majority of time, photographs can be captured simply through the use of available light. Other times it may be necessary to make use of supplemental lighting, or to take control of the lighting which is already present in the chosen setting. There are a number of ways to accomplish this. First, it is essential that the photographer recognize the presence of hard and soft light present within the scene and make a decision as to where he or she needs the light to be coming from in order to best capture a fair and accurate image of the subject matter.

Hard Light

Hard light is direct light which is cast upon the subject matter. It is typically intense and not controlled. Hard light is usually responsible for significant shadows and for washing out the color of objects. Hard light can be either natural or artificial.

Examples of hard light include direct sunlight and camera flash emitted directly at the subject matter. Significant glare can also be considered hard light and can impact image exposure.

Soft Light

Soft light is indirect light which is cast upon the subject matter. It is less intense than hard light and results in less shadow being produced and less washing away of color. Soft light can be either natural or artificial light. Sunlight which is softened by an overcast sky or light emitted from a camera flash which has been softened using a piece of white paper or cloth over the flash-head are examples of soft light. Typically, this softening of light is referred to as diffusion.

Diffused Light

Diffused light is light that has been softened from its original emission and is less direct and less intense than hard light. It typically presents the truest color and does not result in washed out or burn sections within the resulting image. Light can be diffused through a number of methods. The most common method of diffusing light is to make use of a light colored, translucent material (such as paper or cloth) and place it between the hard light (sunlight, flash, etc.) and the subject matter, thereby decreasing the light intensity and softening the light which is directed up on the subject matter.

Electronic Flash Unit

When it is necessary to add light to a photographic setting, an Electronic Flash Unit (EFU) or built-in digital flash is typically utilized. **EFU**s are small, powerful, convenient light sources which are color balanced for daylight (**Figures 6.1-6.3**)

88

Figure 6.1: DSLR with attached EFU
Figure 6.2: EFU, detached from camera
Figure 6.3: EFU, attached to camera using flash-sync cable

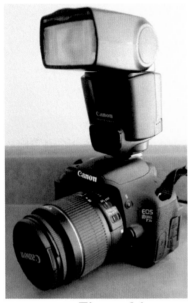

Figure 6.1

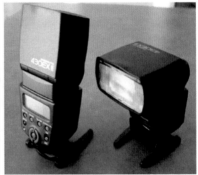

Figure 6.2

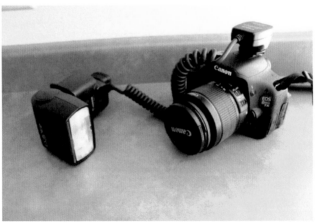

Figure 6.3

Some EFUs have built in flash-diffusers that can be placed over the flash head and used to soften the flash discharge. If a flash diffuser is not a component of an EFU, they can be found and used as accessories.

Bounce Flash

Many EFUs have articulating (up and down) and panning (side-to-side) heads which allow for the light emitted from them to be directed at a specific angle to the subject matter. Doing so will permit the photographer to maintain control over soft and hard light which is directed upon the subject. Many times this involves using simple geometry to bounce the flash off of an object (wall, ceiling, hand, sheet of paper, etc.) and direct it at the subject matter from another angle, rather than directly at the subject. When using **bounce flash**, it is important to remember to only bounce the light off of lightly colored surfaces or else the subject matter will likely be awash in a lighter color of the reflected color which the flash is bounced off of.

Red-eye Reduction

When human or animal subjects are photographed using flash photography, oftentimes the resulting image includes the subject matter exhibiting pupils which are red. This is referred to as **red-eye** and is created as a result of light being reflected off of blood vessels at the rear of the eye (**Figure 6.4**). The angle most responsible for red-eye is when the camera flash is deployed directly in front of the subject matter, causing the hard light to be reflected off of the rear of the eye and back towards the camera lens.

Figure 6.4: Example of red-eye

Red-eye can be reduced through changing the angle at which the light is directed at the eye/subject matter or through photo manipulation after the image has been produced. However, since photo manipulation is not something which is desired within crime scene photography, it is suggested that when live subjects are photographed, that direct light not be emitted at an angle which would result in red-eye. Bounce flash is an excellent technique for assisting in reducing the presence of red-eye.

Positioning Light Source

Red-eye is not the only concern that a crime scene photographer must consider with regards to flash angle. Where the photographer positions the light source/EFU is very important to ensuring that the final image exhibits the image desired by the photographer. Improper placement of the flash can result in glare, color washout, distracting shadows and an overall misrepresentation of the true appearance of the subject matter. For this reason, it is often beneficial to make use of an EFU which may be detached from the DSLR camera and synced to it via a sync cable for off-camera use. While nearly all cameras have built-in flashes which are sufficient to illuminate the majority of situations, other times it is beneficial to have a more intense flash and one which can be removed from the camera and positioned at various angles. When confronted with reflective objects such as windows, glass,

polished metal, etc. it would be inadvisable to direct flash straight at the subject matter less the image result in a flash error whereby the flash leaves a bright illumination upon the subject matter. Since the built-in flash cannot be repositioned to allow for the use of bounce-flash, making use of a detachable EFU will allow the photographer to point the flash at an angle which is convenient and proper. **Figures 6.5-6.11** show a macro-photography scenario where the camera is set up on a tripod directly overhead of physical evidence and a scale. In Figure 6.6, the flash is illuminated directly overhead as though still attached to the camera. Notice the harsh glare which occurs as a result. Figure 6.7-6.10 are taken with the flash at various angles and positions around the evidence. Note the resulting shadows which detract from the image and fail to properly document the subject matter. Figure 6.11 was taken without the use of a flash and instead was taken using a slower shutter speed, allowing more light to enter the camera but necessitating the use of a tripod, due to the tripod rule. As can be seen, sometimes a flash is not necessary, but rather it is more beneficial if the photographer is able to make proper use of the available light to best illuminate and represent the subject matter.

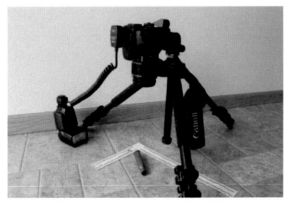

Figure 6.5: DSLR and EFU, attached with sync cord, positioned on a tripod for a macro photograph.

Figure 6.6 Figure 6.7

Figure 6.8 Figure 6.9

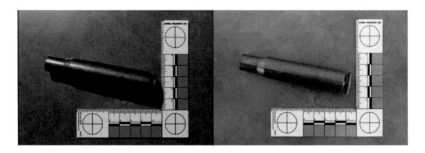

Figure 6.10 Figure 6.11

However, sometimes there is not sufficient ambient light available to allow for proper illumination of the subject matter. It may also be improper to use directly overhead or attached flash to illuminate the subject, due to the previously discussed

reasons. In such cases, it is important for the photographer to be aware of how best to properly position a light source or flash in order to best document the subject matter intended to be photographed. (**Figure 6.12, Figure 6.13**)

Figure 6.12: Photographing a footwear impression at night, using an attached flash (and additional lighting provided by flashlight)

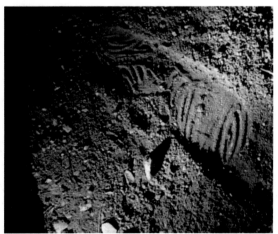

Figure 6.13: Photographing the same footwear impression making use of only light applied across the subject from the side, versus a camera flash from overhead.

Oblique Light Photography

Sometimes making use of available light does not make for a successful image. When that happens, properly utilizing flash photography may result in additional detail being visualized. **Figures 6.14-6.16** show use of an EFU to bring out subject matter detail. As was previously discussed, if a flash is deployed overhead there will be little or no detail exhibited. However, if **oblique lighting** is used additional detail becomes visible. Oblique lighting is illumination of the subject from an angle as opposed to having light emitted directly down or up through the subject. To accomplish this, a light source (EFU) is held outside of the field of view and deployed directly across the surface of the subject matter, from the top, bottom, left or right of the image. The result will be shadows occurring within indentations or depressions present on the subject matter, resulting in added contrast and better visualization of detail.

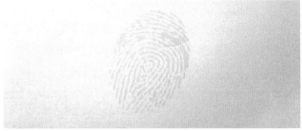

Figure 6.14: Flash deployed at 45 degrees to subject

Figure 6.15: Flash deployed at an oblique angle across the subject matter

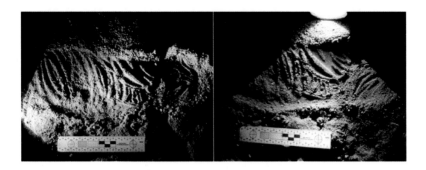

Figure 6.16: Light deployed at various oblique angles to best capture the details of a footwear impression

Therefore, each situation is unique and the photographer must take into account what information is needed and what the intent of the photograph will be. Then, it is the photographer's responsibility to determine whether or not use of a flash will add to or detract from that intent. Sometimes the photographer might even be questioning whether or not sufficient light is even possible? How far can light travel? How much light is required to illuminate a subject? These questions border on more advanced topics but can best be summarized through discussion of the inverse-square law.

Inverse-square Law

The farther that light is transmitted from the source the less light that is available to illuminate the subject. Light dissipates exponentially the farther from the source that it is. This is referred to as the "**Inverse Square Law**". Simply stated, the law states that "The intensity of illumination decreases as the square of the distance of the light source decreases." For example, a specific amount of light covering a given area at a distance of one foot from the source must cover four times the area at two feet, nine times the area at three feet, and sixteen times the area at four feet (**Figure 6.17**).

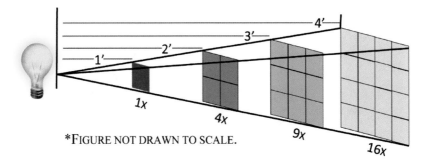

*FIGURE NOT DRAWN TO SCALE.

Figure 6.17: Inverse Square Law (Figure courtesy of Dana Cecil)

This is an important concept for the photographer to remember, especially when confronted with a large, open area which requires photo-documentation. It may not be possible for a single flash from the EFU to be capable of illuminating such an expansive (or dark) area. In such an instance, a photographer will have to resort to more advanced skills such as painting with light, extended exposure settings, and reflected light. For now it is enough for the photographer to recognize that basic photography skills may not be enough for every situation which is confronted within crime scene photography.

Remember: The farther away a subject is from the flash, the more light that will be required to light the object. Light dissipates exponentially as it moves away from the originating source.

Painting with Light

At times, the photographer may be confronted with an expansive area which is not well lit and which requires more illumination than the camera flash can provide to result in an exposure which will allow for proper documentation of the subject matter (**Figure 6.18**). If there is enough ambient light,

it may be possible for the photographer simply to take a photo of the scene using an extended shutter speed. However, sometimes this will not prove to be enough to sufficiently illuminate the intended subject matter. In these cases, it may be possible for the photographer to employ a technique called **painting with light** (Figure 6.19).

Figure 6.18: Large, outdoor area, photographed at night, using only the attached camera flash.

Figure 6.19: The same scene photographed using the painting with light technique.

Painting with light is a photographic technique which will allow for a large, dimly lit scene, to be photographed using multiple flashes, or additional light sources, while the camera shutter remains open until the additional lighting required is completed, resulting in one, properly illuminated exposure being produced.

To employ the technique of painting with light one will require the assistance of another individual, or two, in addition to some additional photographic equipment.

Painting with Light Technique

- Begin by defining the area to be photographed.
- Attach the camera to a tripod, properly positioned to enable the entire subject area to be included within the exposure.
- Detach the EFU from the camera body.
- If the camera has a shutter speed setting of *B* (bulb), set the camera to it.
- Set the lens opening to *f*3.8 or larger (if possible).
- If the camera has a shutter release cable, attach it to the shutter release (or if supplied with a remote, you will use this to lock the shutter open during exposure).
- Look through the viewfinder and identify the field of view, identifying the outermost boundaries to the left and right of the intended image.
- Attempt to focus the camera (manual focus) at the halfway point into the field of view, by illuminating the intended area with additional lighting.
- Hand the EFU to an assistant, who will remotely "fire" the unit away from the camera. (If it is possible to have an additional person, give them another EFU, so that there will be two flash units deployed to light the scene.)

- With one assistant standing behind the camera/tripod/photographer, have them prepare the EFU to "fire".
- Upon receiving a verbal "ready" signal from the person operating the EFU, the photographer will depress the shutter release (or activate the remote) to open the shutter.
- The first flash illumination will then be activated from above and behind the camera lens, toward the subject.
- The EFU operator(s) will then position the EFU at intervals along the previously identified outer edges of the intended field of view, to the right and to the left of the photographer, attempting to provide even illumination across the field of view, using caution not to position his/her body between the area being illuminated and the camera lens. (Doing so will cause silhouettes or ghost figures) (Figure 6.20).
- Always remember to point the EFU away from the camera and toward the scene to be illuminated, never back toward the camera. (Doing so will cause the image to be washed out).
- After the scene has been sufficiently illuminated through the use of this technique, the shutter is released (either through the shutter release cable or remote).
- Repeat as necessary until obtaining an image which is best and most evenly illuminated.

If your camera equipment does not include the benefit of a shutter release cable or remote, there are ways to still employ the technique of painting with light, albeit acting more expeditiously. The additional options include manually pressing and holding the shutter release for the bulb setting (although camera shake will likely be an issue, resulting in a blurred image), or a more likely method of success would be to

set the camera shutter speed to its longest setting (typically 30 seconds) and then to make use of the self-timer. With this method, upon receiving the command of "ready" from the assistant holding the EFU, the photographer depresses the shutter release and the camera begins to count down to opening the shutter, making use of the self-timer. Once the shutter opens, the photographer tells the assistant "GO" and the remainder of the process continues as above, with the only caveat being that it all must occur within 30 seconds. So, it is very important to have everything set up prior to depressing the shutter release.

Figure 6.20: Ghost figures produced by the assistant using the EFU in the field of view, while attempting the painting with light technique.

Using an Alternate Light Source

Clean white light is necessary for basic observation and documentation; however, often specialized lighting is necessary to document the crime scene and its associated evidence. **Alternate light sources (ALS) (Figure 6.21)** are light-emitting devices supplied with colored filters that filter the source light so that items can be viewed with light of a narrow wavelength range, rather than at the usual full spectrum ("white light") viewing range. **(Figure 6.22).**

Figure 6.21: Small, handheld Alternate Light Source (ALS)

ALS will assist with visualizing:
- Fluids and biological matter
- Fibers and some hairs
- Bruises or bite marks
- Nearly invisible bloodstains

102

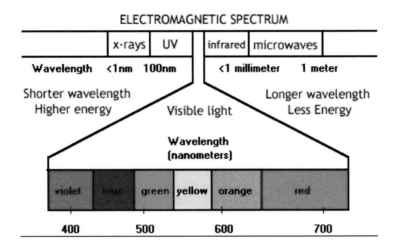

ELECTROMAGNETIC SPECTRUM

Figure 6.22: The electromagnetic spectrum

Other types of alternate lighting may be used at crime scenes, such as ultra-violet (UV) light or infra-red (IR). In any of these instances, the light sources are there to provide an alternate method of illumination, each requiring the photographer to adapt to the method chosen and employed. It may require the use of a camera **barrier filter** in order to record the image. (**Figure 6.23**)

Figure 6.23: Camera barrier filter

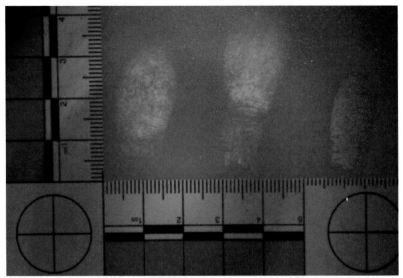

Figure 6.24: Example of visualizing latent fingerprints utilizing fluorescent fingerprint powder and a handheld ALS.

A barrier filter is used to filter non-desired light wavelengths and instead isolate the specific wavelength visualized by the alternate light source. Barrier filters can be in the form of goggles worn by an individual, or by a filter placed over a camera lens. Through the use of a barrier filter, a camera is able to record the image of subject matter visualized through the use of an alternate light source, as it would appear to someone making use of barrier filter goggles. The most common use of this method is with regards to locating, processing, visualizing, and identifying latent fingerprints. (**Figure 6.24**).

Summary

Lighting, whether supplemental or ambient, is a key component of the exposure triangle. In order to capture a successful image, the photographer must make use of and/or

104

understand how to add/subtract/control light. There are many methods of doing this and some are more complex than others. In the end, the photographer must be able to look at the image and testify that it is a fair and accurate representation of the subject matter as it appeared to them at the time that the image was exposed.

Application of Chapter Concepts

1. Using natural light (turn your flash off), photograph the following:
 a. A fingerprint (without scale & with scale)
 b. A quarter (without scale & with scale)
 c. Text on hand written note (only without scale)
 d. A Serial number on an object or appliance (only without scale)

2. Repeat the same four photos but use your flash on your camera.

3. Repeat the same four photos but try to use a flashlight or lamp to create oblique lighting.

4. In a dark location, necessitating the use of flash photography to properly illuminate, place measurement tents/placards 5', 10', 15', 20', 25' and 30' away from the camera/flash. Take a photograph using the camera flash and note the distance that the flash illuminated. Attempt to calculate if your image is representative of the Inverse Square Law discussed within the chapter.

5. Take a series of nighttime outdoor photographs of a scene with some existing light. The scene needs to be at least 30 feet deep. All photographs in this series should be taken from the same location, with the camera set on

a tripod. To minimize camera shake you may want to use the self-timer feature to count down to shutter release.

 a. Meter the scene and take a photo using the BUILT-IN flash.

 b. Take a photo at f8 @ 5 seconds, with same flash

 c. Take a photo at f8 @ 10 seconds, with same flash

 d. Take a photo at f8 @ 15 seconds, with same flash.

 e. Take 4-6 photos using the "painting with light" technique. (Remember if you are not using a remote or cable release, to use the self-timer feature to count down to shutter release to avoid camera shake. Be sure your partner that is working the detached flash is prepared to begin illumination prior to depressing the shutter release.) Have some fun with this one. Experiment with different numbers of flash uses. Keep a record of the number of flash exposures used in each photo so you can see how using additional illumination helps "paint" the scene.

Chapter 7

Photographic Ranges and Perspectives

Chapter 7: Photographic Ranges and Perspectives

Key Terms:

- ABFO Scale
- Close-up Photograph
- Linear Distortion
- Midrange Photograph
- Overall Photograph
- Scale of Reference

<u>Introduction</u>

In keeping with the story telling theme, the first photos taken at a scene should not be of gore or an item of physical evidence, instead it should be of the overall crime scene. Instead, they should set the stage for the beginning of the story. As with any story, there needs to be an introduction, a body and a conclusion. There should be a specific methodology which is adhered to when one sets about taking crime scene photos. Chapter 8 will discuss photography methodologies and the establishment of standard operating procedures. However, before we can discuss the methodology associated with ensuring that photography efforts are properly conducted, the ranges and perspectives which relate to proper subject matter image capture must be discussed. For now, it is necessary to understand that photography of a crime scene should be performed in a systematic manner to ensure that all necessary photos are taken. Photographs should be taken before any evidence is moved. The best approach to crime scene photography is to sequentially take overall, midrange and close-up photographs.

Overall Photographs

Overall photographs are exposed with a wide angle lens or in a fashion that allows the viewer to see a large area in the scene, and are taken at eye-level (Figure 7.1). Their function is to document the condition and layout of the scene as found. They help eliminate issues of subsequent contamination (e.g. tracked blood, movement of items). They are typically taken by shooting from the four corners of the crime scene. If indoors these are typically taken from the corners of the room, shooting towards the center (Figure 7.3). If outdoors, these are typically shot in the direction of a cardinal heading (North, South, East, West) or from the four corners of the structure (Figure 7.2). These will often capture the entire scene. If not, additional photographs from an appropriate vantage point can be taken.

Overall photographs should set the scene as the beginning of the storytelling efforts and should include street signs and addresses if possible. Also, it may be necessary to not only take overall photos facing the building or scene in question, but also overalls facing away from the scene, showing the area surrounding the scene.

Figure 7.1: Overall photograph

Figure 7.2: Series of overall photographs of house exterior

110

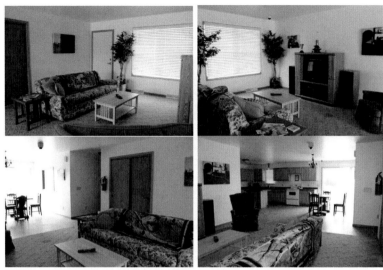

Figure 7.3: Series of overall photographs of house interior
(Photos courtesy of Dana Cecil)

For larger areas or large structures, overlapping photos are recommended to ensure that the entire area is documented. If evidence markers are utilized to identify the location of evidence at the scene, photos should be taken before and after their placement. Note, for instance, that in the photos which compose Figure 7.3, there is no evidence marker present during the initial overall photos. However, Figure 7.1 is a re-take of an overall perspective, showing the placement of an evidence marker. This ensures that the subsequent mid-range and close-up photos are more easily understood.

Midrange/Evidence Establishing Photographs

The function of **midrange photographs** is to frame the item of evidence with an easily recognized landmark (Figure 7.4). This visually establishes the position of the evidence in the scene, with relationship to the item's surroundings, and as a result are oftentimes referred to as "evidence establishing"

photographs. They are the most overlooked photograph in crime scene work, and when remembered to be taken, they are often incorrectly taken. They should be photographs of the evidence prior to movement or manipulation and should never include a scale of reference in the photo. The evidence establishing photograph is not intended to show details, simply to frame the item with a known landmark in the scene. The close-up and the evidence establishing photograph should work hand-in-hand.

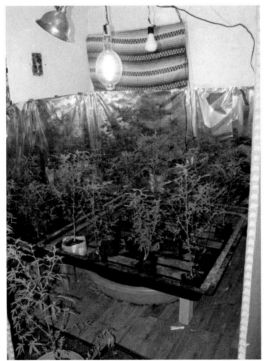

Figure 7.4: Mid-range photograph

These photographs document the relationship of evidence items to other items within an area, and should include an easily recognizable landmark when properly composed.

112

Close-up/Macro Photographs

The function of **Close-up photographs** (sometimes called "comparison", "examination", or "macro" photographs) is to allow the viewer to see all evident detail on the item of evidence. This photo should be close and fill the frame with the evidence itself. They are typically taken with and without a scale of reference (**Figure 7.5**). It is extremely important that photographs of this type are first taken without a scale of reference, and then with a scale of reference.

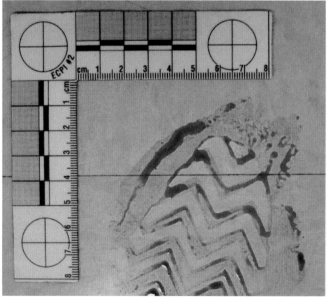

Figure 7.5: Close-up photograph with a scale of reference

The first photo shows the scene prior to contamination or manipulation by the photographer or crime scene personnel. The second includes a scale of reference with which the viewer is able to gauge size of the item presented within the photograph. This scale will allow for a 1:1 ratio reproduction of the photograph (IE: 1 inch equals 1 inch). Failure to

photograph the close-up without a scale prior to incorporating a scale in the photo could result in the photo being inadmissible because of the allegation of scene tampering.

Sometimes a scale of reference is not necessary, and it may even be acceptable to not photograph an item with the camera parallel to the subject matter. If the intent of the photograph is to visual describe an item. Sometimes this is best done through taking a photograph at an odd angle. If done, remember that the intent of the photograph is to best describe the item, and not to assign size or dimension to it. (**Figure 7.6, Figure 7.7**)

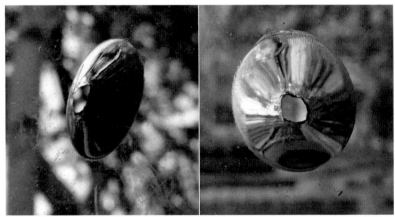

Figures 7.6 and 7.7: Examples of appropriate photography without a scale of reference and taken at an odd angle to best visually explain the item being photographed.

The previously mentioned photographic ranges are used anytime there is an item of evidence which is important and will have a bearing on the investigation. While there might be a variety of perspectives photographed, any photograph taken at a crime scene will fall under one of the above ranges. For instance, photographs taken from the reported position of a witness would fall into the "overall range" category. While photos taken to show the address of a residence would fall into

the "midrange" category if it showed more than simply the numbers/letters and also showed the façade of the house or entry to the home. However, if it was only of the letters/numbers this would fall into the "close-up" range.

Figure 7.8: Photograph which is neither a mid-range, nor a close-up.

One of the most common errors of crime scene photography is taking a photo which is in between useful ranges. If a photo is intended to show items in relationship to surroundings, then it should be arranged as a midrange photograph. If a photograph is intended to show detail or unique markings, then it should be arranged as a proper close-up or macro photograph. **Figure 7.8** shows a common error in crime scene photography. While this photograph is acceptable and commonplace within artistic photography, it is neither a mid-range photograph (since it does not show the item in relationship to surroundings), nor is it a macro photograph (since it does not show the features specific to the item being photographed (in this case, marijuana, which would include close-up photo of unique botanical features).

There may be an instance where such a photograph assists in telling a story ("This is a marijuana plant") but a photograph making use of proper range and perspective would likely be more appropriate.

Scales of reference

Scales of reference are utilized within close-up/macro photographs to permit the viewer of the resulting image to interpret the precise size and dimension of the subject matter photographed. In order for this to be possible, there are two primary concerns.

1.) The scale of reference which is used must be scientific and accurate as to measurement and dimension.
2.) The photographer must make proper use of the scale of reference within the photographic efforts.

Failure to either use a proper scale, or to properly use a scale, results in the scale of reference simply becoming a distraction present within the photograph, rather than having any specific forensic value.

Forensic scales which are available through a variety of vendors have specific features present upon them which assist the photographer with macro-photography efforts. Figure 7.9 shows several commonly used forensic scales of reference.

Proper Use of Forensic Scales

It is not enough for a photographer to simply make use of a scale of reference within a macro-photograph. He or she must also do so properly, or else it defeats the use of and intent

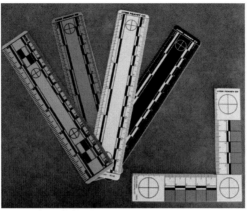

Figure 7.9: Examples of forensic scales of reference

behind the use of the scale of reference. In order for a scale to be of benefit, it must be possible to determine the size and/or dimension of the object(s) within the image. Forensic scales contain circles which will appear to elongate if photographed from an improper angle. Also, the lines representing termination of each centimeter can be extended to match up and intersect with the lines of the perpendicular centimeter intersection lines. If the lines do not meet and form a right angle then the photography angle was not directly overhead or parallel to the subject matter.

An **ABFO scale** is an example of a specific type of forensic scale of reference (seen within Figures 7.6-7.9). An ABFO (American Board of Forensic Odontology) scale is an L-shaped piece of plastic used in photography that is marked with circles, black and white bars, and 18-percent gray bars to assist in distortion compensation and provide exposure determination **(Figure 7.10)**. For measurement, the plastic piece is marked in millimeters. Note how the circles tend to look elongated and elliptical as well as how the imaginary centimeter termination lines do not result in right angles.

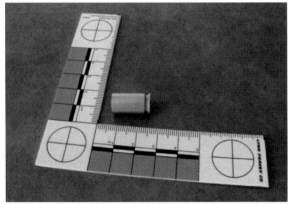

Figure 7.10: Improper use of ABFO scale as to evidence plane and camera angle.

Simply being at the correct angle is not sufficient to count as proper use of a scale of reference. The scale must also be present at the proper plane in order to be of the greatest benefit. If the scale is not presented at the proper plane, there will be distortion present. This is especially important when photographing impression evidence or items of evidence exhibiting three-dimensional characteristics **(Figures 7.11-7.12)**

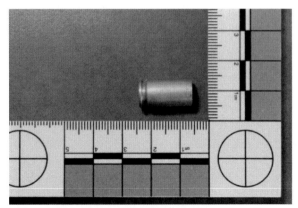

Figure 7.11: Proper use of ABFO scale as to plane and camera angle (props used to raise scale)

Figure 7.12: Use of props to raise ABFO scale to proper plane.

As displayed in the previous figures, sometimes it may be necessary to raise a scale of reference in order to have it be of correct use. The opposite is also true. In the event that there is impression evidence, such as footwear or tire impressions, it will be necessary to arrange that the scale be at the same plane as the impression. Therefore, a small trench will need to be dug to the same depth as the impression, (after photographing the evidence prior to disturbing the surroundings), and the scale of reference placed within the excavated area, ensuring that the scale of reference is present on the same plane as the intended subject matter. This will result in the greatest forensic benefit of the resulting image.

Linear Perspective Issues

All crime scene photographs can be grouped into one of the three previously mentioned photographic ranges: overall, mid-range, or close-up. However, the perspective and angle of the camera when documenting each of the aforementioned ranges

will determine the eventual usefulness and integrity of the images.

Of primary concern is what is referred to as **linear distortion**. Linear distortion is the misrepresentation of spacing and dimension associated with composing a photograph which exhibits items which appear to be in line with one another, moving away from the photographer's position (Figure 7.13). This is not necessarily an issue unless the photographer is attempting to take the photograph to document distance or spacing. If that is the case, the photographer will need to shoot the items from several angles so as to properly represent the items and spatial arrangements (Figure 7.14).

Figure 7.13: Linear distortion as a result of camera perspective (Photo courtesy of Dana Cecil)

Figure 7.14: Proper spatial arrangement documentation based upon camera perspective. (Photo courtesy of Dana Cecil)

Panoramic

With many of today's modern digital cameras, there remains an additional perspective option available to the photographer.

When confronted with expansive scenes, or when attempting to give an overall perspective of the scene, a **panoramic** setting may be an option. An image which shows a field of view greater than that of the human eye, may be termed panoramic. This typically means that the image has an aspect ratio of 2:1 or greater (sometimes as high as 10:1), since the image is at least twice as wide as it is high. However, since this setting essentially digitally stitches together a number of photographs, thus creating one long photograph of the scene, the photographer must properly account for the use of this method within his/her documentation.

As can be seen below, a panoramic photo will bend the scene to "fit" into one photo. Take for instance, the photo of the road

in the panoramic photo below. The road runs parallel to the photographer, but in the photo it appears to curve and run away from the photographer at a 45-degree angle.

Also, in the photograph of a famous U.S. landmark, the individuals who were seated to the left and to the right of the photographer, appear to be in front of the photographer, and the crowds near them appear to extend into the distance. However, in reality, they extended to the left and to the right of the photographer, and did not actually appear in front of the photographer at all.

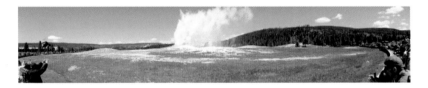

These distortions of reality, in the name of documentation, must be properly explained and recorded in order to ensure that a fair and accurate recording of the scene is taking place.

Summary

Every crime scene photograph should have an intended purpose. In order to properly capture the intent and purpose behind an image, the photographer must ensure that he or she is composing the photograph properly and capturing the intended subject matter from the correct range and perspective. Failure

to identify proper photographic range and perspective may result in the photographs having no forensic value.

<u>Applying Chapter Concepts</u>

1. Photograph an object from different perspectives. Try to show it in a true fashion. Then show it from a number of perspectives that distorts it or causes confusion.
2. Line up two objects 25 feet apart. Take a photo of them without any depth clues. Now add depth clues (like chalk marks or cones every five feet).
3. Take a macro-photograph of an object making use of a scale. Try raising and lowering the scale to above and below the subject matter and take note of the resulting image distortion.

Chapter 8

Methodology

Chapter 8: Methodology

Key Terms:

- In Situ
- Iterative Process
- Photo Identifier
- Photo Log
- Standard Operating Procedures (SOPs)
- Visual Storytelling

Introduction

The majority of this text has been dedicated to how to properly compose a photograph and to make use out of the features present within a modern DSLR camera. In addition, correct ranges and perspectives have been discussed. However, it is not enough to simply know how to compose a photograph and know what perspective or range to expose the image from. The photographic methodology of crime scene documentation is the subject of this chapter.

Other Photographic Considerations

Other than image composition, what other matters must be considered by the photographer? Suggestions include:

- What photos should be taken?
- In what order should they be taken?
- What additional documentation must accompany photographs in order that they be admissible within court?
- What department/agency standard operating procedures exist which relate to the photographic documentation process?

Standard Operating Procedures

The photographer should be aware of agency or departmental directives and/or standard operating procedures (SOPs) which exist pertaining to crime scene documentation. Many of these surround written documentation associated with photographs taken, as well as downloading, archiving and retrieval of digital images.

Photo Identifier

A **photo identifier** is a handwritten or agency developed sheet which lists pertinent case information for the photographs to follow. It is important to remember to take a photograph of a photo identifier as the first photo taken at the crime scene. Taking a photo of this as the first photo of a case will ensure that personnel are familiar with which photographs pertain to which case, and who they were taken by. With today's digital media, it is often the case that several, cases are photographed on a digital media card prior to download. Photographing a photo placard will serve as a separator between the cases, so that case photos will not become commingled. Many commercially available photo identifiers also include color references and scales of reference which can be used by the photography for metering and for pre-exposure image composure **(Figure 8.1)**.

Visual Storytelling

As was previously discussed, the most effective crime scene photography involves photographs which most thoroughly tell the story of what was present and what possibly occurred. This process is referred to as **visual storytelling (Figure 8.2)**. A proper story includes an introduction, a body and an appropriate conclusion that does not leave the reader hanging

and desiring additional information. The photographer would be wise to remember this concept when planning which photos to take and in what order to take them.

Figure 8.1: Commercially available photo identifier

Order of Taking Photographs

The photographer should establish SOPs which relate to the order in which he or she takes photographs when confronted with a crime scene. Having said this, the SOPs will have to be somewhat flexible in order to allow for variances which could exist due to scene or environmental concerns.

After exposing a proper image of a photo identifier which lists pertinent case information, the photographer should begin telling the story by setting the scene. This typically includes photographing a street sign to orient the viewer. Next, overall photographs are exposed of the exterior of the scene, taking special care not to disturb any evidence present. If the photographer notes fragile or transient evidence during this

process, this is where the flexibility comes into play and the photographer should modify his or her SOPs to allow for the proper documentation of the transient or fragile evidence.

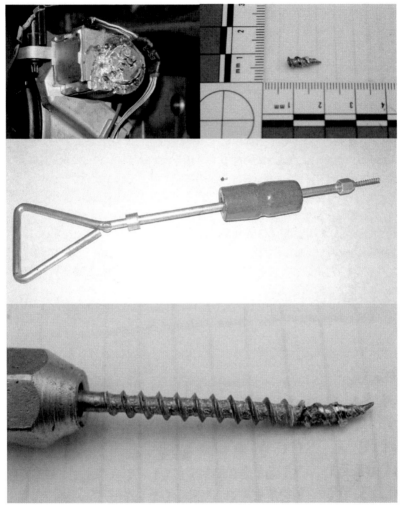

Figure 8.2: A collection of photos which attempt to tell a story.

Regardless of the order in which they occur, the scene photographs and photographs taken of the evidence contained within it, must be photographed **in situ**, or as it was found. Photographs should document an unaltered state and a scene which has not been moved or disturbed.

Taking overall photos is much less intrusive to a crime scene than taking close up photos (due to movement of items and addition of scales of reference). Therefore, it is important that the reader realize that although typically listed together, not all ranges of photographs are taken together or at the same time during a scene investigation. After the initial scene survey has been conducted, and before a detailed search or examination is undertaken, the crime scene should be photographed. However, this will only include the "overall" photographs, and if there are items of evidence which have been located, then mid-ranges can be taken from a safe position. Close-ups are not typically taken until a thorough search of the scene has been conducted, unless the item is of a transient nature. As the reader can see, there is some back and forth business to crime scene processing.

Photography is an Iterative Process

Photograph s should be taken of all known evidence, using evidence establishing and evidence close-up photos. As crime scene efforts continue, if additional items are discovered in later stages, the photographer should return and document them fully, including additional overall photographs if needed. As such, crime scene photography is an **iterative process**. This means that the acts of crime scene observation, searching and photography of discovered items are repetitive processes. Each repetition is referred to as an "iteration" and the results of one iteration are then used as the starting point for the next

iteration. Using this process, the photographer will ensure a thorough and systematic documentation of the crime scene.

Create photographs that fully demonstrate the results of additional examinations (e.g. latent prints, bloodstain pattern analysis, trajectory analysis).

Photo Log

Regardless of the perspective or range taken, each photograph taken at a crime scene should be documented on a **photo log**. A photo log is a permanent record of all information pertaining to documentation by photographs. Department policy often dictates what is found within a photo log, however if there is not a policy in place pertaining to such matters, the following is offered as a suggestion. (**Figure 8.3**)

The information which should be included on a photo log includes:

- Title and information block consisting of: Date/Time/Case Number/Agency Name
- Photo equipment used
- Numerical ordering of each photo taken
- Brief description of photo taken
- Direction facing for each photo taken
- Approximate distance from subject matter in each photo taken
- Shutter speed, aperture setting, ISO (If photographs are taken in digital format, documenting such information is not as imperative, as it will be digitally recorded when each photo is taken, as part of the digital file for each photo.

Photograph List Case # []

	Month	Day	Year	Page
Location of Incident		City		of Time
Victim's Name		DOB		
Photographer/ID #		Scribe/ID #		
Camera, Lenses, and Flash Used				

#	Description of Photo	Tripod (Y or N)	Lens Used (if zoom, length set on)	Flash (yes/no & normal, bounce, or off camera)	Direction Facing	F/Stop	SS	Distance from subject
1								
2								
3								
4								
5								
6								
7								
8								
9								
10								
11								
12								
13								
14								
15								
16								
17								
18								
19								
20								
21								
22								
23								
24								

Figure 8.3: Photo Log Example

Color Reference

When photographing injuries, paint transfer evidence, and other evidence which is color specific, it is essential for the photographer to make use of a color reference card (Figure 8.4).

Figure 8.4: Commercially available color reference card

Remember:

- *Document the entire scene in-situ as soon as possible using overall photographs.*
- *Photograph all fragile evidence as soon as possible.*
- *In the documentation stage, photograph all known evidence using evidence establishing and evidence close-up photos.*
- *As items are discovered in later stages, return and document them fully, including additional overall photographs if needed.*

- *Create photographs that fully demonstrate the results of additional examinations (e.g. latent prints, bloodstain pattern analysis, trajectory analysis).*
- *Always use a photo placard on the first shot of each roll to demonstrate admin data.*
- *Do not include yourself or other persons in the photographs, if possible.*
- *Always use a crime scene photo log.*
- *Shoot all close-up photographs with the use of a tripod.*
- *Close-up photos should be taken with and without a scale of reference.*
- *Be sure that the scale is on the same plane as the item of evidence being photographed.*
- *The subject matter should be parallel to the film plane/camera to eliminate distortion caused by skewed angle photographs.*
- *If in doubt, photograph it!*

Summary

Choosing the photos to be taken and the order in which to take photos is as important as having the resulting image be properly exposed. If scene documentation is incomplete, the "story" will have gaps. It is the photographer's responsibility to insure that proper visual storytelling is conducted in order that a thorough and systematic photographic effort has occurred.

Photography is a technical skill and as with any technical skill, the more times that a skill is performed (correctly) the more proficient an individual becomes at the skill. So, whether you are reading this as someone new to photography, or are a seasoned veteran simply looking for an occasional reference, hopefully this text will be of value to you. Continue to take photos and the photos will continue to improve!

Applying Chapter Concepts

1. Pick a day over the next week and tell the story of that day in photos only. Carry your camera from the time you get up till the time you go back to bed. Document the events of the day.
2. Attempt to tell a story using no more than 24 photos.
3. Take a photo of a red object with and without a color reference card. Note any variations.

Chapter 9

Challenging Environments

Chapter 9: Challenging Environments

Key Terms:

- Backscatter
- Refraction
- Polarizing filter
- Strobe

Introduction

While many would consider shooting in any crime scene environment to be a challenge, there are several situations which are especially problematic, and which require the photographer to employ additional techniques or to make use of equipment not yet discussed.

If the location to be photographed is outdoors, then almost certainly the photographer will have to contend with varying environmental conditions. These typically can be categorized into lighting and precipitation.

Lighting has been sufficiently covered in previous chapters however suggestions on how best to combat the challenges of precipitation will be addressed within this chapter.

Rain and Snow

There will be many times during an individual's career when he/she is called upon to document an outdoor scene during the midst of a precipitation event. Whether that includes rain or snow, the photographer should prepare and adapt in a similar fashion. This adaptation will include considerations for both the person and his/her equipment.

Equipment Considerations

The most important consideration is protection of one's equipment. There are a number of suggestions for accomplishing this. The options available to the photographer include the following:

- Shoot under protective covering (umbrella, raincoat, overhang, etc.)
- Use waterproof camera (commercially available either as a complete unit or as a protective housing for camera equipment).
- Adapt current equipment to enable it to function in cold/rain (typically through insertion into a waterproof housing or clear plastic bag).

Adaptive Photographic Techniques

Once one has protected his/her equipment, the next concern is how to properly photograph the subject matter in order to best document a fair and accurate representation. Which method to employ will largely depend upon available lighting. In Chapter 2, we discussed stop-action photography and documenting subject matter making use of shutter-priority mode. If the subject matter is well-lit or during daytime, this would be an appropriate time to take manual control over one's camera and choose a fast shutter speed. The slower the shutter speed, the more blurring that will occur as a result of the falling precipitation. However, if a fast shutter speed is chosen, it will freeze the action (precipitation) resulting in only minor visual inconveniences. The faster the shutter speed the less blurring which will occur. Remember, that a proper exposure is still necessary, so it may not be possible to choose an extremely fast shutter speed if there is not much available light, because it will not allow for a significantly large aperture opening through

which to allow the necessary light into the camera, thus giving a properly exposed image. This is why shutter priority mode is a wise choice. In this setting, the photographer chooses the shutter speed (fast) and the camera will choose the proper aperture setting which will result in a properly exposed photograph.

If the image is instead attempted at night, or with minimal light, and if there are no moving components within the field of view, it would be best to have the camera on a tripod and to use a very slow shutter speed, and large aperture setting, in order to best make use of ambient light. If the shutter speed is exceptionally slow (3+ seconds), and if a flash is not deployed, there will be minimal blurring.

The above techniques are best practiced prior to one needing them to document something of evidentiary value. Remember to practice, practice, practice!

Extreme Heat or Extreme Cold

Just as with personnel, extreme temperatures can be fatiguing to equipment. Extreme heat or cold can drain camera batteries, melt or crack components and accessories, and possibly even render equipment unusable (**Figure 9.1**). Of additional concern is the transfer of equipment from one extreme to the next. Imagine one has his/her equipment stored in the air-conditioned confines of their vehicle or office and then removed and immediately put to use in outdoor temperatures exceeding 100 degrees Fahrenheit. Or similarly, the equipment is stored within a heated vehicle or office and then is immediately put use within sub-freezing outdoor conditions. In either case, there will likely be a fogging of lenses which occur, in addition to the possibilities of battery drain or camera shutdown occurring. (Some newer equipment is programmed

to auto-shutdown in the event of extreme heat or cold to preserve vital internal digital components.

Figure 9.1: Extreme cold and extreme heat can impact camera equipment

Pay close attention to manufacturer warnings and suggestions, contained within equipment owner's manuals, pertaining to the use of equipment in extreme conditions.

Absent that, it is suggested that one transition his or her equipment between environments, allowing for the equipment to have a **short** period of acclimation to the new temperature prior to deployment. This will assist in reducing any lens fogging which may occur. In extreme cold, it may work best to allow the equipment to adjust a bit to the colder temperature, but it is suggested that one keep the camera battery in one's pocket or an area of warmth until just prior to utilizing (also suggested to keep an extra battery or two to rotate, since battery life in the cold will be reduced). This will ensure that there is a greater deal of battery life available.

As a rule, it is best to store the equipment in room temperature environments with minimal humidity, but again, refer to the manufacturer's recommendations relating to the equipment being put to use.

Aquatic Photography

Sometimes a photographer will be confronted with instances where items are located within, or end up in water. When this occurs, it is appropriate to photograph the items of evidence within the aquatic environment, prior to removing them. In order to accomplish this, the photographer must adapt his or her photography skills and photography equipment for a vastly different environment from that which is more commonly encountered. Not all underwater evidence will require a photographer to actually enter the aquatic environment. In some instances he/she may be able to make use of previously discussed methods to photograph underwater objects without ever getting either equipment or self wet.

Above-water Photography

If the subject matter is within shallow water, and there is no way for the photographer to submerge his or her equipment to document it, he or she can make use of a **polarizing filter** to photograph the scene. This lens accessory is typically used when it is necessary to photograph an object submerged at shallow depth in relatively clear water. The filter eliminates the reflections of the water's surface, allowing the camera to see beneath it, without the necessity to submerge the equipment.

Underwater Equipment Considerations

When it becomes necessary to submerge camera equipment into an aquatic environment to document a scene there will obviously be some equipment considerations to be taken into account. There are basically two options when it comes to photography equipment for underwater subject matter. The photographer can adapt his or her camera for underwater photography. This is typically accomplished through the use of commercially available waterproof and pressure-proof housings (**Figure 9.2**). The other option which exists is to purchase photography equipment designed specifically for underwater use (**Figure 9.3**).

Shallow-water Photography

Sometimes, when the subject matter is located in shallow water, it may not be sufficient enough to photograph from outside of the water, making use of a polarized filter. However, the water may also not be deep enough to allow for, or require the photographer to submerge themselves within the marine environment. In these cases, simply submerging the equipment will typically suffice (**Figure 9.4**).

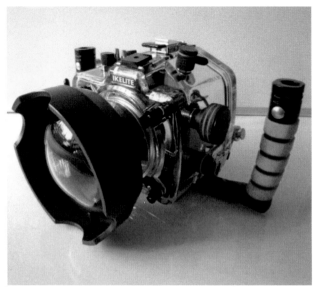

Figure 9.2: Example of adapting photography equipment for underwater use, utilizing a waterproof/pressure-proof housing.

Figure 9.3: Example of a commercially available camera designed to be waterproof/pressure-proof (to a depth of 60 feet).

Figure 9.4: Photograph of evidence located in 1 foot of water, taken by submerging only the camera into the marine environment

Although waterproof equipment may be necessary, the other nuances of underwater photography, (which will be discussed subsequently within this chapter), will not typically be issues encountered at shallow depths. In these cases, it is typically enough to simply submerge the equipment and photograph the subject matter as intended. It is however suggested that the photographer limit his/her movements so as not to stir up sediment that could possibly cloud the water and impact photographic clarity. There is one undesired drawback to this form of photography, which will typically appear in shallow water photographs, and that is the subject matter appearing in mirrored duplication, as it is reflected upon the surface of the water (**Figure 9.5**).

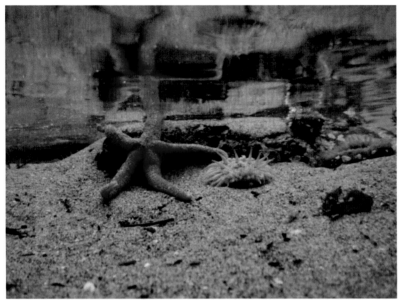

Figure 9.5: Underwater photograph, taken in 10 inches of water. (Note reflection off of surface)

Submerged Photography

When the subject matter to be photographed is in water deep enough to necessitate the submersion of both photographer and equipment, more adaptation will be necessary. Since this text is dedicated to photography skills and techniques, the reader is referred to texts pertaining to SCUBA and public safety diving in order to ascertain what equipment and training considerations exist for personnel in order to safely operate in an underwater environment.

Assuming that the photographer has been properly trained and is properly equipped as to his/her person, the remaining considerations pertain to equipment requirements and photographic techniques necessary to successfully photograph in a completely submerged environment. These challenges are

144

best discussed by breaking them up into specific underwater environmental characteristics which the photographer will need to be aware of and able to adapt to and overcome.

Environmental Challenges

A great deal of light is reflected off of the surface of water and thus never passes into the depths below (**Figure 9.6**). However, light rays that are able to pass from air to water will have a reduction in speed, thus resulting in the light rays becoming subsequently bent. This is referred to as **refraction**. Refraction occurs whenever a beam of light strikes a plane surface between two substances which have different optical properties (such as air and water). Water refracts light rays in a manner unlike glass or air, in that underwater objects are magnified. For this reason images and distances are distorted (**Figure 9.7**).

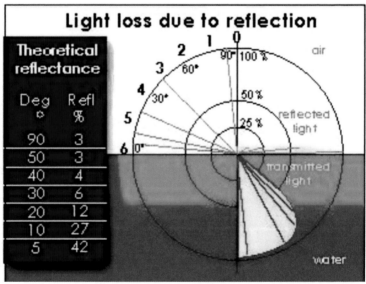

Figure 9.6: Light loss due to reflection (Adapted from "Forensic Photography: The Importance of Accuracy")

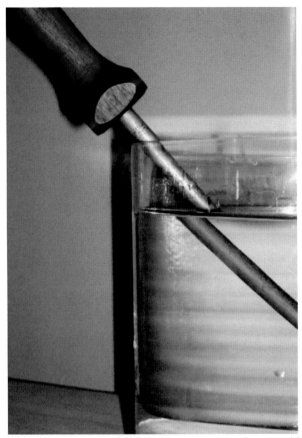

Figure 9.7: An example of the distortion and magnification which results from light refraction in water.

In fact, items located underwater will appear 33% larger than actual size due to refraction. This level of refraction and magnification occurs because water is more dense than air.

Water density contributes to another challenging characteristic of the underwater environment. Since water is considerably more dense than air, whatever light is able to penetrate the surface (and thus not lost to reflection), will not be able to penetrate at the same distance (or brightness) as above water.

This contributes to the apparent subsequent loss of color as depth increases as the available light is dispersed throughout the medium.

As depths increase, daylight rays of red, orange, and yellow are filtered out by the water, leaving blue and green rays (**Figure 9.8**). Even in the clearest waters, primarily only blue and green wave lengths penetrate at a depth greater than 60 feet (**Figure 9.9**).

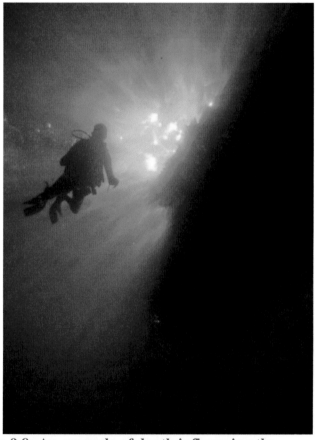

Figure 9.8: An example of depth influencing the appearance of underwater colors.

In addition to color and lighting issues, oftentimes the environment will create difficulty for the underwater photographer. Silt, sediment, algae and pollution can create "black /brown diving" conditions where visibility can be less than 1 or 2 feet. (**Figure 9.10**)

It is especially important for the photographer to have good diving skills to ensure proper buoyancy so as not to disturb the environment and obscure the intended images.

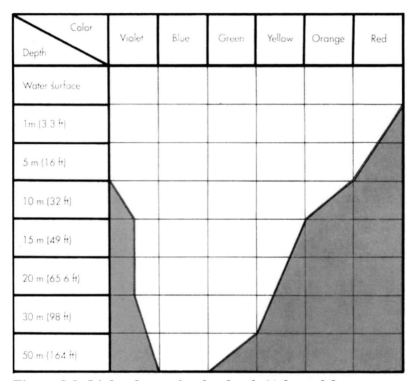

Figure 9.9: Light absorption by depth (Adapted from "Forensic Photography: The Importance of Accuracy")

148

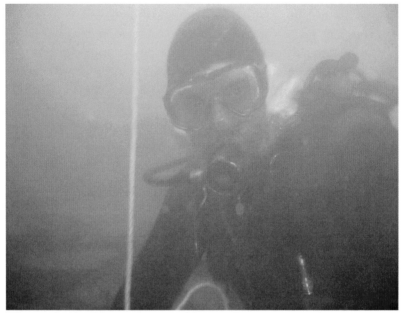

Figure 9.10: Diver obscured by underwater environment.

Overcoming Environmental Challenges

Because natural sunlight is rapidly absorbed or scattered by water, the addition of artificial light is quite often essential for two reasons.

 1.) To illuminate the subject
 2.) To obtain the true color of underwater objects and
 surroundings.

Artificial light is added to an underwater scene through the addition of a waterproof EFU (sometimes referred to as a **strobe**), attached to an underwater camera or underwater camera housing (**Figure 9.11**). Light from an EFU will produce all of the wavelengths of the spectrum and, therefore, reflect the true color of the item underwater.

Figure 9.11: Waterproof EFU attached to underwater camera housing.

Returning to our earlier discussion of a "true and accurate" representation of the subject matter, this is a good example of the necessity to document when certain equipment and techniques are made use of. Since the photographer's eyes will not see the underwater subject matter in actual color, but rather in the colors able to be seen at the depth that the object is, due to the previously mentioned reasons for color reduction and loss. Therefore, if a flash is deployed, it will reflect subject colors that are not an accurate representation of what the photographer actually saw, but which are instead more accurately portrayed as to subject color and detail, if necessary and appropriate.

Position of the artificial light source is especially important underwater. The EFU should be permanently mounted or hand held so that it will be close to the subject but off to one side,

angling the light at 30 to 45 degrees toward the subject. This is important because when photographing underwater with flash, the same problems are experienced as when taking flash photos during a blizzard or heavy rainstorm. Particles in the water reflect light back to the camera lens, obscuring the image with spots and haze. This is referred to as **backscatter** (**Figure 9.12**).

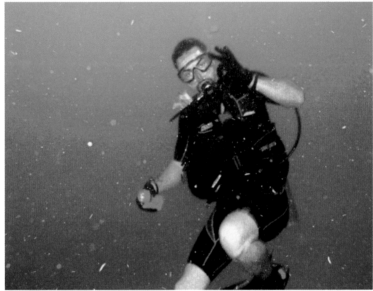

Figure 9.12: Example of backscatter.

When photographing (or shooting video) with natural light at depth, color-compensating filters can be placed upon the camera to compensate for colors lost due to depth. Red filters are used for blue cast and magenta for green cast, thus eliminating the cyan bluish-green cast associated with underwater photography (**Figure 9.13**). Typically, this is only utilized for shots covering a considerable distance, and not with close-up photography. The need for compensating filters is eliminated if sufficient artificial lighting such as electronic flash is used.

Figure 9.13: Color compensating underwater filter

There is one final consideration as pertains to photographing in the underwater environment. In addition to assisting in ensuring that one's equipment is waterproof, it is wise to place photographic equipment into a dunk tank comprised of the same water type and temperature into which the equipment will be immersed, for 5-10 minutes prior to entering the marine environment. The equipment should be checked for waterproofing just prior to entering the water and the equipment should be transitioned directly from the transition tank into the marine environment, with as short of an out-of-water window as possible, in order to best reduce subsequent fogging or clouding of the lenses.

Remember:

1.) *Stay shallow: Reduce the color loss from the light reaching the subject (if possible).*
2.) *Use a strobe: For a still camera, use the strobe to replace the light that is lost underwater.*

3.) <u>Stay close to your subject</u>: Keep the distance between subject and camera as close as possible.
4.) Use the fastest shutter speed possible.
5.) Work as close to the photo subject as possible.
6.) Always test equipment for water tightness prior to submerging.

<u>Fire/Post-fire Documentation</u>

In some instances, a photographer may be called upon to document the scene of a suspicious fire or a post-incendiary event. In essence, the storytelling and photographic principles associated with this undertaking remain similar to those previously discussed. It is however, worth mentioning that it is a suggested practice to also document firefighting and response efforts as a component of the visual storytelling process (**Figures 9.14 and 9.15**). This is especially important if the fire turns out to have been nefariously started, and thus the collected evidence is used to hold the individual(s) criminally and civilly (liability and financially) responsible. Documenting efforts and response also aide in eventual debriefing and analysis on how to improve future efforts.

Another important visual storytelling component which is an important consideration associated with fire/arson photography is for the photographer to document efforts taken to secure the scene after firefighting efforts have ceased. Typically, the scene will remain an investigatory site, or at the very least, a hazardous location. Therefore, it is important to document efforts to keep the area secure and safe from intrusion (**Figure 9.16**).

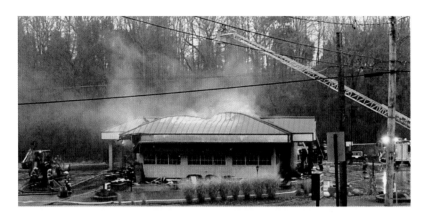

Figure 9.14: Documenting firefighting efforts and response

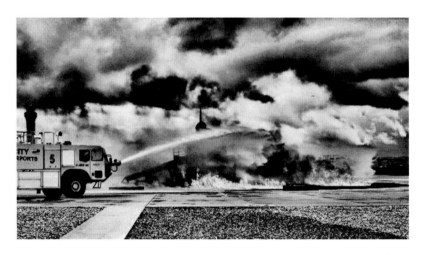

Figure 9.15: Documenting firefighting efforts and response (Photo courtesy of Amy Charbonneau)

Figure 9.16: Documenting post-firefighting attempts to secure the scene

The patterns left behind on structure materials will typically aide in determining where the fire originated, how hot it burned, where it traveled to, and other clues and components associated with an incendiary event. Therefore, it is of paramount importance that patterns present be properly documented (Figure 9.17).

Additional areas of consideration include protection of equipment from heat and steam (consider using a properly transitioned waterproof housing) and being cognizant to meter for the intended subject matter when preparing to take photos, since the overwhelming majority of the subject matter will often be very dark/burned and may thus require additional

lighting to be deployed. The same considerations can be used when confronted with an area of high contamination (methamphetamine lab). Making use of a camera housing will protect the photography equipment and aide in post-event decontamination.

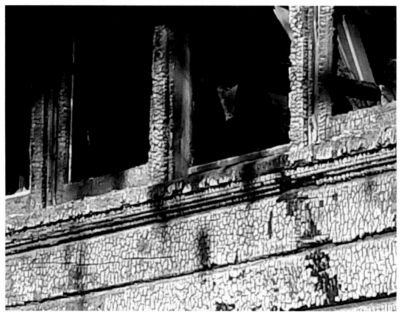

Figure 9.17: Documenting fire patterns and burn types. (In this case, the presence of "alligatoring" a typical fire pattern found on wood materials).

Post-blast Photography

If called to respond to an incendiary scene, which is post-blast in nature, the important photographic component remains to document proper visual storytelling. The photographic techniques employed remain fairly basis and have been adequately covered to this point. The reader has been provided this section as a visual example so that the necessity of

documenting a few important perspectives and ranges are addressed.

One perspective of paramount importance related to documenting, processing and investigating a post-blast scene is an aerial or overhead view (Figure 9.18). This is primarily important in order to enable one to ascertain the area to be searched and documented. It also aides in provided a very graphic visual descriptor of the event, with regards to visual storytelling.

Additional perspectives or matters to be documented include anything which will assist in explaining where the blast occurred, what/who was impacted, extent of damage, explosive force present (high or low explosive), and anything else necessary to prepare proper visual storytelling documentation (Figures 9.19-9.21).

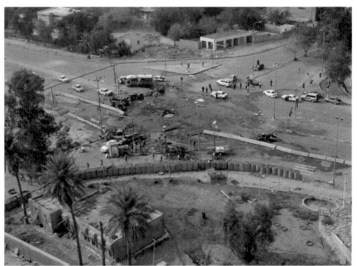

Figure 9.18: Aerial view of a post-blast event, showing the area impacted and area to be processed.

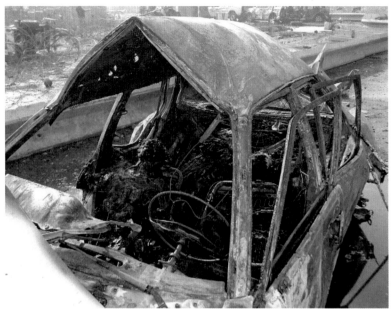

Figure 9.19: Photo showing upward blast (inverted V-shape of car roof) typically associated with a car bomb found within the passenger compartment.

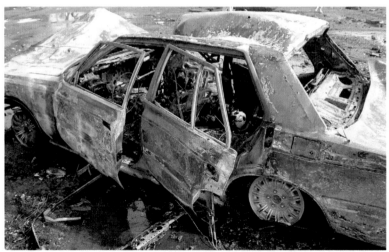

Figure 9.20: Same vehicle as above, from another angle. Note doors blown open and tires burned off.

158

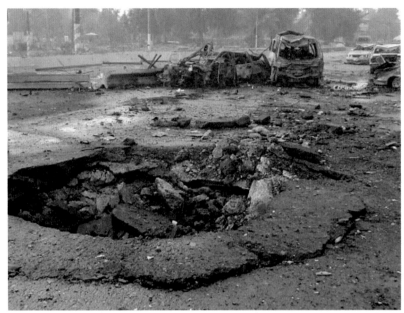

Figure 9.21: Crater caused by the explosion, located at the point of origin, prior to the vehicle being moved as a result of the explosion.

Summary

Shooting outdoors and in precipitation events presents a photographer with a wealth of challenges and opportunities to put his/her photographic skills to the test. The same can be said for underwater photography, should a photographer find himself/herself in a situation which provides him/her with an opportunity to put both equipment and personnel to the test.

As with all photographic documentation, as has been mentioned throughout the text, of paramount importance is that the documentation be a true and accurate visual storytelling of the subject matter. If the photographic process requires significant alteration or efforts to visualize the subject matter (filters, lighting, etc.) proper documentation (photo log) is

extremely important, so as to allow the evidence to be legally admissible. The legal admissibility of evidence will be addressed in Chapter 10.

Applying Chapter Concepts

If unable to adapt current photographic equipment for underwater use, purchase a disposable waterproof camera at a local retailer (typically 24 exposures). Locate an area of clear water that is approximately 12-18 inches deep (a bathtub will typically work if nothing else is available). Attempt the following photographs:

1.) Take a photograph of an item resting on the bottom, with the camera directly overhead, but out of the water.

2.) Take a photograph of the same item, with the camera directly overhead, but with the camera lens submerged. Note the differences in size and clarity of the object between the two images.

3.) Stand an 8-10" tall item in water which is a minimum of two feet deep. Submerge the camera into the water and take photographs from 1, 2, 3, 4 and 5 feet away from the object, with the camera pointed horizontally (not overhead).

4.) Repeat the photographs taken in #3 (above), but with the lights off and making use of a flash. Note how flash intensity diminishes related to distance to object.

Chapter 10

Legal Aspects of Photographs

Chapter 10: Legal Aspects of Photographs

Introduction

The first recorded criminal case introducing photographs as identification evidence was *Udderzook vs. Commonwealth (1874)*. Criminal cases have shown the importance of color since the 1960's (*State vs. Conte, 1968)*, when in a case depicting graphic wounds to the victim, photos were admitted as evidence. Criminal cases have continued to make use of photography to document evidence and create a visual story of what occurred, or was found at, the scene of a crime, however the technology associated with the process has changed significantly over time.

Goodbye Film

Digital photography began being utilized in the criminal justice community approximately 15 years ago, although at that time the only affordable option was low-resolution digital equipment. Many agencies saw the benefit of digital photography's universal format, however realized that the resolution available was not appropriate for identification, examination, and courtroom purposes. Therefore, the majority of agencies chose to keep film cameras until the resolution of digital systems began to approach that found in film resolution. During this transitory era, many agencies required that both film and digital images be taken of pertinent evidence.

Processing film is now a thing of the past, as is submitting film as photographic evidence.

162

An April, 2010 survey of all 50 State and U.S. Territory crime lab systems, conducted by the University of Wisconsin-Platteville, revealed the following:

- The first state to convert its labs to digital was California, in 2000. (Alaska also converted later the same year).
- Kentucky was the only lab to still claim a significant amount of evidence submittals associated with film, and to retain a "full service photo lab" within its crime laboratory for film evidence processing (Conversion should be completed late 2015).
- Over half of the state crime labs within the U.S. had a transitional period between film and digital, which required the ability to process both, between the years of 2002-2006.
- 31 of 50 states had converted by the end of 2005.
- The average conversion date was April of 2005.
- 42 of 50 had converted by the end of 2008.
- The final 8 converted during 2009, with the State of Wisconsin being the last to do so.

SWGIT

To assist with the legal complexities, and to ensure the proper use of this new technology, in 1999, the Federal Bureau of Investigation established the Scientific Working Group on Imaging Technologies (SWGIT). The work group is composed of approximately 25 representatives from local, state, and federal law enforcement agencies, as well as imaging specialists from academia. The mission of SWGIT is "to

facilitate the integration of imaging technologies and systems in the criminal justice system by providing definitions and recommendations for the capture, storage, processing, analysis, transmission, and output of images." SWGIT has been working for over a decade to assist those within the criminal justice system to transition from a film-based to a digital-based society. Of particular interest and usefulness is a document developed by SWGIT, entitled "Recommendations and Guidelines for use of Digital Image Processing in the Criminal Justice System." All of SWGIT's documents are available online at the International Association for Identification website (www.theiai.org).

Legal Admissibility

The legal requirements for the admissibility of digital images as evidence within court are the same as that for film images. The majority of legal challenges surrounding digital images have mostly been concerned with processed images. SWGIT's policy is that any changes to an image which are made through digital image processing are acceptable within forensic applications as long as the following criteria are met:

- The original image is preserved;
- The processing steps are logged when they include techniques other than those used in a traditional photographic darkroom; and
- The end result is presented as an enhanced image, which may be reproduced by applying the logged steps to the original image.

One of the biggest areas of concern, and the one with the largest associated price-tag, is the area of digital image archiving and chain of custody of digital images. Digital images must be downloaded and archived to a computer system, which requires significant data storage abilities.

The FBI requires the following with regards to digital submissions:

- Documentation of image source
- Documentation of capture device (scanner, digital camera, etc.)
- Documentation indicating the image or photograph is an original capture
- File properties as follows:
 o A file format without compression or with lossless compression (RAW, TIFF)
 o A minimum of 8-bit for grayscale images and 24-bit for color images.
 o A resolution that meets or exceeds 1000 pixels per inch (PPI) when calibrated to actual size (1:1).

Fair and Accurate Revisited

For almost 150 years, graphic images of evidence associated with crime scenes have been presented within courts. In each case, admissibility of the images is decided upon by the presiding judge or magistrate. Photographs are almost always admitted due to the fact that they are typically only representative of items of evidence and are not evidence itself. The single most important requirement of a photograph in order that it be admissible is that it be a "fair and accurate" representation of the subject matter within the resulting image.

As has been discussed within the confines of this text, there are a number of matters which must be considered when attempting to compose an image which is fair and accurate. The photographer must consider:

- Photographic range
- Photographic perspective
- Depth-of-field
- Lighting conditions
- Movement
- Color representation
- Resolution
- Image format

When a photographer has stopped to consider and incorporate all of the aforementioned pieces of the puzzle, it will then be possible for a fair and accurate representation of the subject matter to be captured.

Summary

While the processes used to capture an image have changed over time, the ultimate goal remains the same, as pertains to photographs used within the criminal investigative process. Ultimately, a photograph must be a fair and accurate representation of the subject matter portrayed. This responsibility rests solely upon the photographer's shoulders and it is his or her responsibility to be prepared to explain the process used to capture the image in such a way that it accurately reflects the scene which the photographer viewed with his or her own eyes. Lighting, resolution, format type, motion, color, depth of field, perspective and photographic range are all components which the photographer must weigh and consider when composing the photograph. If all have been

properly implemented and considered, then it is likely that the image will be ruled admissible as evidence within the court.

Application of Chapter Concepts

1. Pick one of the following cases and give a summary of the case and how it relates to photography. Concentrate on the specifics regarding how the case impacted the legal admissibility of photographs in court.

 The cases to choose from are as follows:
 a. *State v. Conte* (1968). (Make sure you are using the correct case/date)
 b. *Green vs. City and County of Denver* (1943),
 c. *Udderzook v. Commonwealth* (1874).
 d. *Luco v. United States* (1859) (some places list this as "Lueo")
 e. *Florida v. Riley (1989)*

168

Glossary

ABFO Scale: American Board of Forensic Odontology (ABFO) scale is an L-shaped piece of plastic used in photography that is marked with circles, black and white bars, and 18-percent gray bars to assist in distortion compensation and provide exposure determination.

Alternate Light Source (ALS): light-emitting devices supplied with colored filters that filter the source light so that items can be viewed with light of a narrow wavelength range, rather than at the usual full spectrum ("white light") viewing range.

Aperture: The opening within the lens which controls the amount of light entering the camera and which is directed upon the image sensor. The aperture setting (lens opening size) is referred to as the *f/stop.*

Aperture Priority Mode: Camera setting where the photographer takes control of the aperture setting of the camera as a priority and has the camera choose the resulting appropriate shutter speed which will ensure a properly exposed image.

Barrier Filter: used to filter non-desired light wavelengths and instead isolate the specific wavelength visualized by the alternate light source. Barrier filters can be in the form of goggles worn by an individual, or by a filter placed over a camera lens.

Bounce Flash: Directing the use of flash using simple geometry to bounce the flash off of an object (wall, ceiling, hand, sheet of paper, etc.) and direct it at the subject matter from another angle, rather than directly at the subject. It is

169

important to remember to only bounce the light off of lightly colored surfaces or else the subject matter will likely be awash in a lighter color of the reflected color which the flash is bounced off of.

Bracket: This occurs after what the photographer considers to be a properly exposed photograph is taken, then he/she will take several additional photos from the same vantage point, of the same subject matter, slightly over and slightly underexposed.

Bulb Setting: Shutter speed setting where the shutter will remain open for as long as the shutter release button is depressed.

CCD: Charge-coupled device (CCD). An image sensor within the camera body which collects and converts the light energy, which is reflected into the camera, into electrons. The surface of each sensor contains millions of photo cells that each record a single pixel of the resulting image, captured by the lens eye when the shutter is opened and closed.

Close-up Photograph: (Sometimes called "comparison", "examination", or "macro" photographs) Allow the viewer to see all evident detail on the item of evidence. This photo should be close and fill the frame with the evidence itself. They are typically taken with and without a scale of reference.

CMOS: Complementary metal-oxide semiconductor (CMOS). An image sensor within the camera body which collects and converts the light energy, which is reflected into the camera, into electrons. The surface of each sensor contains millions of photo cells that each record a single pixel of the resulting image, captured by the lens eye when the shutter is opened and closed.

Composition: consciously selecting the subject matter which appears within the field of view in a manner which contributes to image value rather than distracting from it. Includes: choosing the photographers viewpoint/viewing angle, choosing which elements are included as subject matter, choosing which elements are excluded as subject matter, and filling the frame with the intended subject matter.

Deep DOF: A photograph which has the majority of the photograph in-focus.

Depth of Field (DOF): The portion of the resulting photograph, from the foreground to the background, which is represented in sharpest focus.

Diffused Light: is light that has been softened from its original emission and is less direct and less intense than hard light. It typically presents the truest color and does not result in washed out or burn sections within the resulting image.

Digital White Balance: Feature which allows the photographer the ability to program the camera to correspond to the correct available lighting conditions present at the scene. The camera will then adjust the resulting image colors, based around the "color" white, so that they are correct.

DSLR: Digital Single-Lens Reflex camera body in which light travels through the camera lens and then strikes a mirror that alternates to send the resulting image either to the camera viewfinder or to the image sensor. By utilizing only one lens, the viewfinder presents the user with an image that will reflect almost exactly (differentiation is typically imperceptible) what is captured upon the camera's image sensor.

EFU: Electronic Flash Unit. Small, powerful, convenient light sources which are color balanced for daylight

Exposure Stops: Exposure stops are precise boundaries which refer to a measured over or underexposure. If a photographer chooses to overexpose the properly exposed image by one exposure stop (+1) they will be doubling the amount of light which will be captured within the resulting image. Conversely, if a photographer chooses to underexpose the properly exposed image by one exposure stop (-1) they will be halving the amount of light which will be captured within the resulting image. This is referred to as "stopping up" or "stopping down".

Exposure Triangle: A graphical representation for the four variables associated with a properly exposed photograph: ƒ/stop, shutter speed, ISO setting, lighting (available or supplemental).If there is a change in any of these variables, the resulting images exposure will be changed.

Fair and Accurate: An image which portrays the intended subject matter in a manner which is true as to color and dimension and is reflective of the way in which the photographer's eye viewed the image at the time that the image was composed.

Focal Length: The minimum distance (in millimeters) between the lens and the image sensor (or film plane) when the lens is focused on infinity (the farthest visible distance from the camera).

F/stop: The size of the aperture opening within the camera lens. The resulting size change of the aperture is therefore a method of exposure control

GIF: Graphical Interchange Format. Image storage format which involves lossless compression which reduces the file size by removing redundant data.

Glass: A slang term for detachable camera lenses typically used on a DSLR.

Hard Light: Direct light which is cast upon the subject matter. It is typically intense and not controlled. Hard light is usually responsible for significant shadows and for washing out the color of objects.

Horizontal Composition: the image is oriented from side-to-side, right to left, or left to right, necessitating that the photographer hold the camera in the customary manner in order to properly capture the intended subject matter.

In Situ: As it was found. An unaltered state. Refers to evidence which has not been moved or disturbed.

Inverse Square Law: The intensity of illumination decreases as the square of the distance of the light source decreases.

ISO: International Standards Organization (ISO) ratings associated with film type/image sensor's relative sensitivity to light. A low number (100) means it is not as sensitive to light and could be used in bright conditions. A higher number (1600) is much more sensitive to light and thus can be used within darker conditions.

Iterative Process: A process which contains repetitions. Each repetition is referred to as an "iteration" and the results of one iteration are then used as the starting point for the next iteration.

JPEG: Joint Photographic Experts Group. Image format type making use of lossy compression. This method involves great compression and reduction in file size, achieving this through the removal of both redundant and extraneous information. The extraneous or irrelevant information cannot be subsequently retrieved during reconstruction for display purposes, and is thus lost. Therefore, this method is inappropriate for criminal justice purposes from a chain of custody standpoint.

Linear Distortion: The misrepresentation of spacing and dimension associated with composing a photograph which exhibits items which appear to be in line with one another, moving away from the photographer's position

Lossless Compression: reduces the file size by removing redundant data. This data can be subsequently retrieved during reconstruction of the image for display, therefore lossless compression results in virtually no loss of information. (Graphical Interchange Format, GIF, would be an example of such a file format).

Lossy Compression: involves great compression and reduction in file size, achieving this through the removal of both redundant and extraneous information. The extraneous or irrelevant information cannot be subsequently retrieved during reconstruction for display purposes, and is thus lost. Therefore, this method is inappropriate for criminal justice purposes from a chain of custody standpoint. (Joint Photographic Experts Group, JPEG, would be an example of such a file format).

Manual Mode: In this mode, the photographer is responsible for choosing both the shutter speed and corresponding aperture setting which will result in a properly exposed image. The camera will not choose either setting and will allow the

photograph to be taken regardless of whether or not the resulting image is over or underexposed.

Megapixel: Reference used within camera specifications which refers to the number of sensors on the CCD or CMOS surface. One megapixel is equal to 1 million pixels. Cameras which have higher megapixel ratings typically are capable of higher resolution photographs.

Metering: This is an evaluative process which is accomplished by depressing the shutter-release half way. The camera will emit infra-red beams which will gauge the available lighting of the subject matter and "suggest" proper exposure settings to the photographer. There are several meter setting options available to the photographer, depending upon the DSLR system he or she is using.

Midrange Photograph: The function is to frame the item of evidence with an easily recognized landmark. This visually establishes the position of the evidence in the scene, with relationship to the item's surroundings, and as a result are oftentimes referred to as "evidence establishing" photographs. They should be photographs of the evidence prior to movement or manipulation and should never include a scale of reference in the photo. The evidence establishing photograph is not intended to show details, simply to frame the item with a known landmark in the scene

Noise: Anomaly which presents itself under higher ISO settings. This is similar to the "graininess" found in film photos taken at higher ISO speeds. It is typically found in dark images as lighter, pixelated sections.

Oblique Lighting: illumination of the subject from an angle as opposed to having light emitted directly down or up through the subject.

Overall Photograph: Are exposed with a wide angle lens or in a fashion that allows the viewer to see a large area in the scene, and are taken at eye-level. Their function is to document the condition and layout of the scene as found. They are typically taken by shooting from the four corners of the crime scene

Overexposed: Images which are exposed to too much light and tend to be washed out.

Painting with light: a photographic technique which will allow for a large, dimly lit scene, to be photographed using multiple flashes, or additional light sources, while the camera shutter remains open until the additional lighting required is completed, resulting in one, properly illuminated exposure being produced.

Photography: To write with light. A mechanical means of retaining vision.

Photo Identifier: A handwritten or agency developed sheet which lists pertinent case information for the photographs which follow it.

Photo Log: A permanent record of all information pertaining to documentation by photographs.

Polarizing Filter: lens accessory which is typically used when it is necessary to photograph an object submerged at shallow depth in relatively clear water. The filter eliminates the reflections of the water's surface, allowing the camera to see beneath it.

Raw: A type of read-only file format. The benefit of these files is that they are virtually unalterable, which is an advantage for archival and chain of custody purposes. The Raw file format is the preferred file format for digital images, due to its unaltered format.

Reciprocal Exposures: Exposure settings which would result in the same image exposure.

Red-Eye: When human or animal subjects are photographed using flash photography, oftentimes the resulting image includes the subject matter exhibiting pupils which are red. This is created as a result of light being reflected off of blood vessels at the rear of the eye.

Refraction: occurs whenever a beam of light strikes a plane surface between two substances which have different optical properties (such as air and water). When light rays pass from air to water they will have a reduction in speed, thus resulting in the light rays becoming subsequently bent. This bending of the light rays will result in underwater objects being magnified and images and distances being distorted.

Resolution: The ability to resolve, or distinguish, parallel black and white line pairs as individual lines. With higher resolution (higher megapixels) the individuality of the lines is able to be determined for a greater distance. Therefore, with greater resolution, there is greater ability to distinguish detail.

Scale of Reference: Are utilized within close-up/macro photographs to permit the viewer of the resulting image to interpret the precise size and dimension of the subject matter photographed.

Shallow DOF: A photograph which exhibits very little of the subject matter to be in-focus.

Shutter: The purpose of the shutter is to control the amount of time that the light is allowed to be focused upon the image sensor. The shutter is activated by depressing a shutter release button (or remote control in some instances).

Shutter Priority Mode: In this mode, the photographer has the option of taking full manual control over the shutter speed setting while the camera will select the appropriate aperture setting which would result in a properly exposed photograph under the selected shutter speed. (referred to as "time value" mode by some manufacturers). This mode is especially useful for taking stop-action photographs where the photographer is confronted with a scenario whereby the photographer, camera, or subject matter is moving.

Shutter Speed: The amount of time that the shutter is permitted to be open.

Soft Light: Indirect light which is cast upon the subject matter. It is less intense than hard light and results in less shadow being produced and less washing away of color.

Standard Operating Procedures (SOPs): Directives, policies or procedures which exist or which are adhered to in order to infuse order and methodology into a process or scenario.

Strobe: Another name for an electronic flash unit (EFU) which is attached to an underwater camera or underwater camera housing and used to add artificial light to an underwater scene.

SWGFAST: The Scientific Working Group on Friction Ridge Analysis, Study, and Technology (SWGFAST). Suggests that

fingerprints and palm prints should be photographed using a resolution which results in a minimum of 1000 ppi across the subject matter area.

SWGIT: The Scientific Working Group on Imaging Technologies (SWGIT). Suggests that crime scene photographers should use a minimum of a 6MP camera to document crime scenes.

SWGTREAD: The Scientific Working Group for Shoeprint and Tire Tread Evidence (SWGTREAD). Suggests that shoe prints and tire tracks be photographed by at least an 8MP camera.

Tripod Rule: when the chosen shutter speed is slower than the chosen focal length of the lens, a tripod should be used.

TIFF: Tagged Image File Format (TIFF). Uncompressed file format which is the next best alternative to the RAW file format in terms of quality. This is still a very large file size, however is not proprietary and is able to be displayed without possession of proprietary software.

Underexposed: Images which are exposed to an insufficient amount of light and are darker than they should be.

Vertical Composition: the image is oriented top to bottom or length-wise, with the image necessitating the photographer to turn the camera sideways in order to properly capture the image

Visual Storytelling: Using digital images to explain an image or subject matter in an effective matter. The process of capturing images which tell a thorough story. As with a story, it is necessary to include images which begin and end the story,

as well as properly document the facts and details present within the body of the story.

References and Additional Reading

Canon Inc. (2012), EOS Rebel T3i Instruction Manual

Dutelle, A.W. (2013) An Introduction to Crime Scene Investigation, 2nd Edition, Jones and Bartlett Learning: Burlington, MA

Dutelle, A.W. (2010) "Say Goodbye to Film", Law Enforcement Technology, Volume 37, Issue 6, June 2010

Redsicker, D.R. (2001), Practical Methodologies of Forensic Photography, 2nd Edition, CRC Press: Boca Raton, FL

Robinson, E.M. (2010), Crime Scene Photography, 2nd Edition, Academic Press: Waltham, MA

Robinson, E.M. (2013), Introduction to Crime Scene Photography, Academic Press: Waltham, MA

United States Department of Justice, (2013), Crime Scene Investigation: A Guide for Law Enforcement, National Institute of Justice. Retrieved from the World Wide Web on June 8, 2015 (http://www.nij.gov/nij/topics/law-enforcement/investigations/crime-scene/guides/general-scenes/welcome.htm)

Weiss, S.L.(2008), Forensic Photography: The Importance of Accuracy, Prentice Hall: Upper Saddle River, NJ

Wisconsin Department of Justice, (2009), Physical Evidence Handbook, 8th Edition, State Crime Laboratories.

Notes

Notes

Notes

Notes

Notes

186

Made in the USA
Monee, IL
19 July 2020